IMAGES
of America

HIGHLAND PARK IN THE 20TH CENTURY

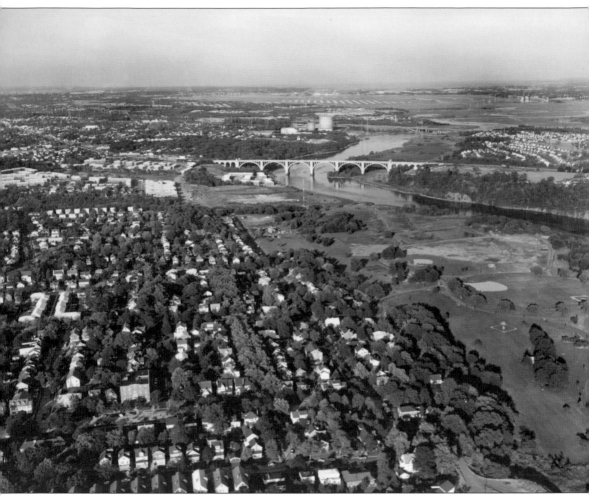

AERIAL PHOTOGRAPH, C. 1965. Perhaps it was Joseph Koye who took this aerial view of the south side of Highland Park in the late 1960s (see page 95). Donaldson Park is at the far right, the Morris Goodkind Bridge carrying US Highway 1 over the Raritan River is at the center, and the tree-lined streets from Cedar Avenue eastward to the Orchard Gardens apartment complex and neighboring town of Edison are on the left. (Courtesy of the Highland Park Historical Society.)

ON THE COVER: This is the left side of a photograph taken in 1948 at a Highland Park Recreation Department–sponsored event at Irving School. Neighborhood children created displays of stuffed animals and won prizes for their creativity. The judges included borough recreation director Austin "Bus" Lepine (back row, right). The entire photograph appears on page 53. (Victor Gabriel photograph, courtesy of the Highland Park Historical Society.)

IMAGES
of America

HIGHLAND PARK IN THE 20TH CENTURY

Jeanne Kolva

ARCADIA
PUBLISHING

Published by Arcadia Publishing
Charleston, South Carolina

Printed in the United States of America

Library of Congress Control Number: 2012939676

For all general information, please contact Arcadia Publishing:
Telephone 843-853-2070
Fax 843-853-0044
E-mail sales@arcadiapublishing.com
For customer service and orders:
Toll-Free 1-888-313-2665

Visit us on the Internet at www.arcadiapublishing.com

*To Eugene F. Rice for all the support you've given me
through each and every year we've spent together.*

CONTENTS

ACKNOWLEDGMENTS

History is a group effort. Collectors, scholars, oral historians, municipal officials, and librarians play vital roles and make valuable contributions of time and money to preserve the documents of our collective past. In Highland Park, the historical society acted as the repository for an ever-growing archive from 1995 to today. I would like to acknowledge many people in Highland Park who have contributed to this effort.

Joanne Pisciotta was born and raised in Highland Park and has previously contributed her knowledge as coauthor of two Arcadia books about Highland Park history. Her dedication to the town of her birth continues unabated. A former librarian at Highland Park High School, Bernice Bernstein saved boxes and boxes of materials from certain destruction and donated them to the Highland Park Historical Society archive. Without those valuable photo albums and historical files, this book, and the two prior books, would not have been possible. William F. Ducca Sr. (1928–2011) was borough clerk for many years and also town historian. Ruth Jansyn was an early proponent of historic preservation as a member of the Highland Park Historical Commission, most active in the 1970s and 1980s, as well as the historical society treasurer and photographer for many years. Eileen Kuhn was also an active archivist and member of the historical commission. Former historical society president Derek Hartwick and former archivist Catherine Bull assisted by keeping the interest in historic preservation going through the last decade of the 20th century. Longtime resident Ellen Rebarber was instrumental in publishing oral histories of other longtime residents in 1998; otherwise, their memoirs would have been lost.

Collectors Juanita Barlow Messer, Gertrude Lauber, Gerald Schultz, Carl Woodward, Betty Sullivan, Linda Kish, Lois Lebbing, Diane Cucci, Carolyn Kuhlthau, Donald Stryker, Charles Dascenzo, Rich Odato, Frank Koye, and others have made numerous contributions to the historical society archives. Arnold Henderson was an active photographer who donated his collection of Highland Park nature photographs before he moved out of town.

And finally, the librarians at the Highland Park Public Library, especially Valeri Drach Weidmann and Jeanne Gallo, now retired, provided immeasurable support for which I will be forever grateful.

The book is organized in chronological order. All but a few of the images contained within are from the extensive collection of the Highland Park Historical Society. They have been amassed largely since 1998, when collecting efforts began in order to produce the first two Arcadia Publishing books: *Highland Park* (1999, Images of America series) and *Highland Park: Borough of Homes* (2005, Making of America series), both coauthored by Jeanne Kolva and Joanne Pisciotta.

INTRODUCTION

On March 15, 1905, the Borough of Highland Park became independent from the larger Raritan Township, of which it had been a part since 1870. Highland Park's drive for independence arose over the issue of public schooling and expenditures for roads. Highland Park had its own school district, established in the 1880s. In the 20th century, there arose a desire for an independent school system and a related dispute over school taxes. The fire department, which formed in 1900, also wanted more autonomous control over its affairs. This redrawing of municipal boundaries into smaller and smaller parcels was taking place statewide.

The 1905 New Jersey census counted 714 Highland Park residents. There were 161 families living in 147 dwellings; 611 were American born and 103 were foreign born. The census noted race. There were 340 white males, 365 white females, 5 black males, and 4 black females. Professions were noted but not specified except for farmers, of which there were 10—off to a good start. The population reached 14,000 by mid-century and remains around that level in 2012.

Over the past 100 years, Highland Park's two square miles of land have been parceled into ever-smaller suburban residential plots. Planned developments included Watson Whittlesey's Livingston Manor, begun in 1906, and the Viehmann Tract on the north side, Riverview Terrace on the south side, Raritan Park Terrace in the triangle between Raritan and Woodbridge Avenues, and East New Brunswick Heights in the Orchard Heights neighborhood. The large apartment complexes built after World War II further consolidated the borough's residential nature. It has taken years of continuously constructing houses and apartment buildings to create the mature suburb.

Highland Park's industries in the 20th century included such companies as a brewery, Johnson & Johnson, the John Waldron Machine Company, Kompak Corporation, Flako Products, Ross Engineering, and the Janeway & Carpender Wallpaper factory. Many smaller operations dotted the town, building everything from typewriter ribbons to brass and glass chandeliers. The borough is the birthplace of the Band-Aid, and Flako Products packaged mixes for baked goods. However, the borough lost most of its industries by the 1960s. The commercial zones along both Raritan and Woodbridge Avenues continue to thrive with a multitude of mom-and-pop shops, several of which, like Bernstein's, Kitchenmeister Florist, and Nanni's Delicatessen, operated for decades.

A town history is also a history of the events that took place here. This book is filled with many events, including soapbox derbies, parades, festivals, sporting contests, ribbon-cutting ceremonies, concerts, and dramatic productions. However, not every day can be a celebration day. Ordinary events such as paving roads, working in the shop, student activities, and meetings are also included. All these snapshots portray the enthusiasm of small-town living. Throughout the 20th century, Highland Park's religious institutions, civic groups, educational facilities, and municipal governance have kept pace with the growth of the town. The trends of local autonomy and control that shaped Highland Park in the past continue to this day.

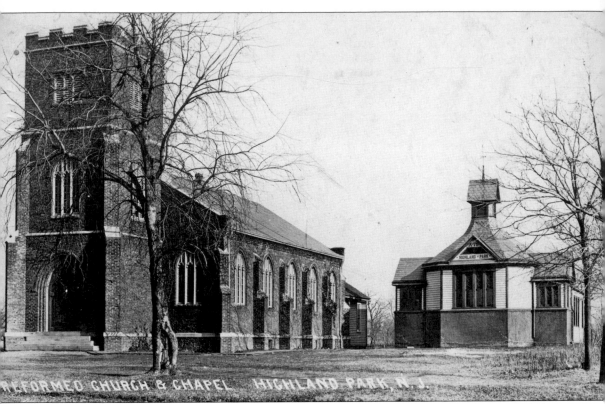

REFORMED CHURCH AND ITS NEW CHAPEL. The historical society recently acquired this 1908 postcard showing the 10-year-old Reformed church on South Second Avenue. The new chapel seen on the right was formerly the first school, which had been designed in 1885 by New Brunswick architect George K. Parsell. In 1907, the church elders purchased the schoolhouse for $37 and relocated it two blocks to the church's side yard. The church, constructed in 1898, was architect Alexander Merchant's first Highland Park building.

One

THE YOUNG BOROUGH

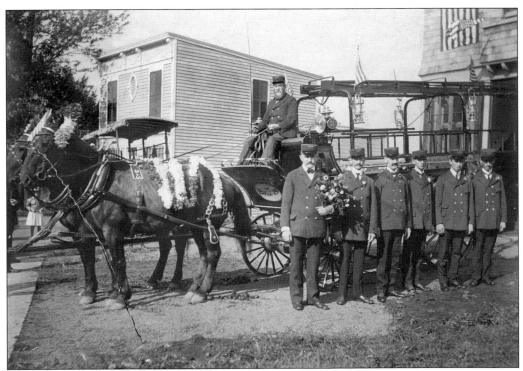

PROUD FIREFIGHTERS, C. 1902. Charles Dahmer, A.J. Gebhardt, James Dunham, Charles Malmros, and August Whitlock are the remaining names listed on this photograph's cropped mat board. These handsome hose company members in their dress uniforms are aligned with their fire cart, which has been pulled out from the firehouse at 141 Raritan Avenue (constructed in 1902). A candy store built in 1895 can be seen behind the horses.

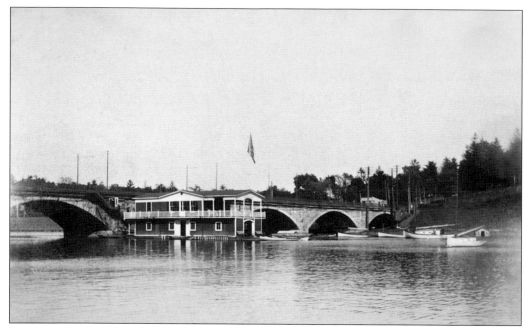

RARITAN RIVER BRIDGE AND BOAT CLUBHOUSE, 1904. The stone arch Albany Street Bridge was built in 1893 and remains a vital connection between Highland Park and New Brunswick. For several decades, the New Brunswick Boat Club tethered its floating, two-story clubhouse to one of the bridge's piers. An iron staircase descending from the bridge's sidewalk allowed access to the boathouse.

N. B. Boat Club Fleet, New Brunswick, N. J.

VIEW DOWNSTREAM FROM THE ALBANY STREET BRIDGE. A New Brunswick Boat Club postcard (postmarked 1908) shows Highland Park's steep and lush riverbank. Club members were from both Highland Park and New Brunswick. The view from the bridge remains the same today, although without boats and with many more houses hidden atop Highland Park's green riverbank.

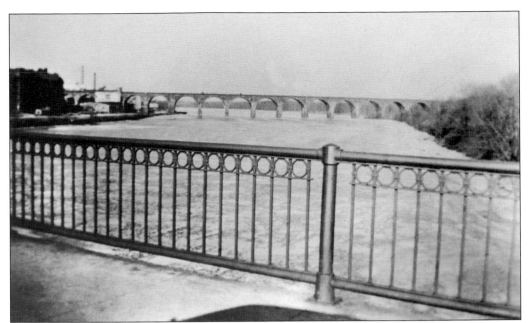

VIEW UPSTREAM FROM THE ALBANY STREET BRIDGE. This photograph prominently features the type of pedestrian-friendly railing that bridges used to have. The view upstream also showcases the 1903 stone arch railroad bridge built by the Pennsylvania Railroad. Longtime resident Carl Woodward took this photograph in 1940.

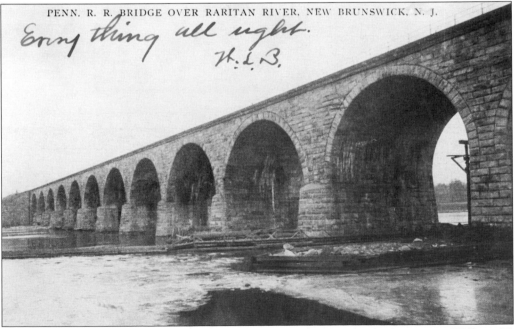

PENNSYLVANIA RAILROAD BRIDGE, 1906. Pennsylvania Railroad's chief engineer, William H. Brown, designed this sizable brownstone arch bridge. This postcard, postmarked in 1906, shows the bridge's appearance before it received a coating of reinforcing concrete in 1942. Two roadways pass under this bridge where the original stone can still be viewed: River Road in Highland Park and Johnson Drive in New Brunswick.

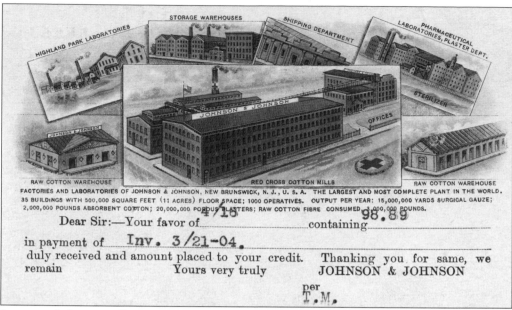

FACTORIES AND LABORATORIES OF JOHNSON & JOHNSON, NEW BRUNSWICK, N. J., U. S. A. THE LARGEST AND MOST COMPLETE PLANT IN THE WORLD. 35 BUILDINGS WITH 500,000 SQUARE FEET (11 ACRES) FLOOR SPACE; 1000 OPERATIVES. OUTPUT PER YEAR: 15,000,000 YARDS SURGICAL GAUZE; 2,000,000 POUNDS ABSORBENT COTTON; 20,000,000 POROUS PLASTERS; RAW COTTON FIBRE CONSUMED 3,000,000 POUNDS.

Dear Sir:—Your favor of _____ containing _____

in payment of Inv. 3/21-04.

duly received and amount placed to your credit. Thanking you for same, we remain Yours very truly JOHNSON & JOHNSON

per T. M.

JOHNSON & JOHNSON PRIVATE MAILING CARD, 1904. The pharmaceutical company conducted business using picture postcards that featured artists' renditions of its factory and laboratory buildings. Highland Park Laboratories (top left) were relatively small buildings. Located on a large lot off North Adelaide Avenue, the dangerous chemicals and processes needed to make mustard plasters were kept far from the crowded urban area of the city across the river.

YOUR OPPORTUNITY

ALL OUR SAMPLE LAMPS TO BE CLOSED OUT AT FACTORY COST

Gas $2.50 **Electric $2.75**

ALSO RICH CUT GLASS SAMPLES
FROM OUR SALESMEN'S TRUNKS

E. M. UNIACK MFG. CO., New Brunswick, N. J.
Cedar Avenue, Highland Park.

UNIACK MANUFACTURING COMPANY. In 1910, the *Daily Home News* reported that a new manufactory was to open in Highland Park. Relocating from New York and taking over an unused factory on Cedar Avenue, the 15-man Uniack Company made luxury brass and glass lamps and chandeliers. Unfortunately, the venture closed after three years. In order to get a comparative sense of the lamp prices, see the 1908 tax bill on page 15.

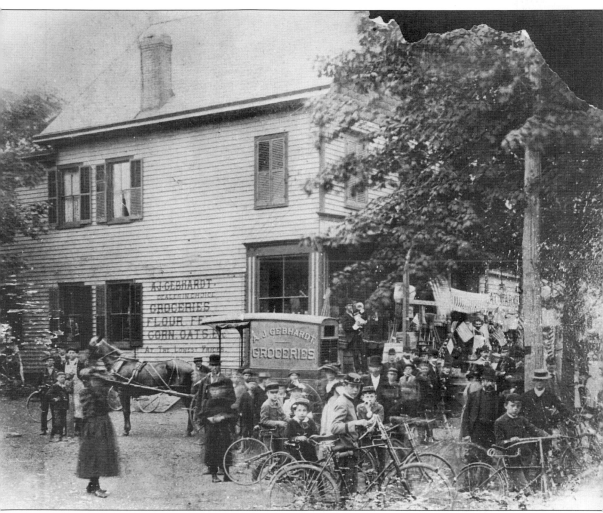

ANTHONY J. GEBHARDT'S GROCERY STORE. Diane Cucci donated this photograph of her relative's grocery store to the historical society. By 1909, its 20th year in business, Gebhardt's Grocery had a team of workers and delivery wagons. With twice-daily postal service, a postcard with a grocery order sent in the morning mail would be received and acted on that afternoon. This photograph also shows a gathering of bicyclists, perhaps at the beginning or end of one of the many races that took place on Raritan Avenue.

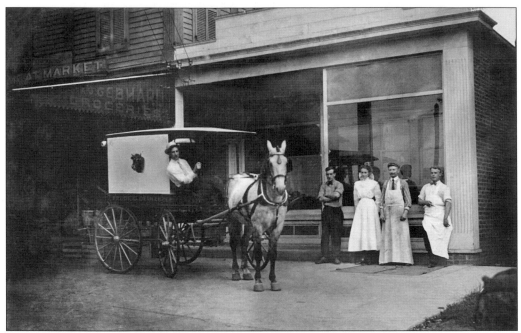

MYSTERY PHOTOGRAPH AND THE DEINZER BUILDING. The store in the top photograph was located next to Gebhardt's Grocery, but it is unidentified, since the picture was taken before the sign went up. It most likely shows Deinzer's butcher shop, which was located at Gebhardt's until 1912. After that, Frank G. Deinzer relocated his butchery to his new, two-story brick building at 116 Raritan Avenue (below). Seen here in the early 1970s, Robert's Florals currently occupies this building. As different businesses are announced on temporary signs, the building continues to bear the Deinzer name in the ceramic plaque centered in the parapet.

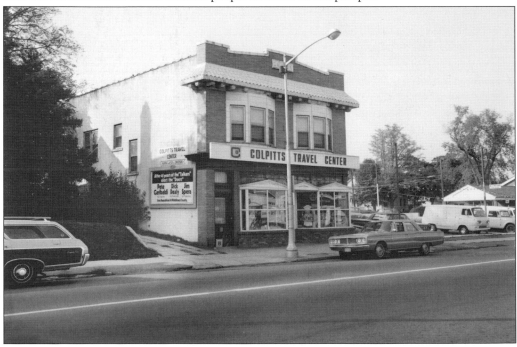

BOROUGH OF HIGHLAND PARK, N. J.
TAX BILL FOR 1908.

Page.................... District No...................

Mr. D. D. Skidmore

Your Tax for 1908 is as follows:

ASSESSED VALUATION.

REAL ESTATE	75	00
PERSONAL		
DEDUCTIONS		
AMT. TAXABLE	75	00

STATE SCHOOL, .21 per cent.........	16
COUNTY, .435 per cent.........	33
SPECIAL SCHOOL, .483 per cent.........	35
BOROUGH EX. .422 per cent.........	32

Percentage, 1.55 per $100.
Poll and Dog Tax Extra.

HIGHLAND PARK, N. J., Oct. 7, 1908.

Taxes are now due, and if not paid before December 20th, 1908, the names of the delinquents will be returned to a Justice of the Peace for Prosecution, and interest at the rate of 12 per cent. and costs will be added.

All appeals must be filed with the Middlesex County Board of Taxation on or before December 20th, 1908. Blank appeal forms will be furnished on application to William A. Spencer, Secretary. Address, 110 Smith St., Perth Amboy, N. J.

Taxes will be received at Collector's office, Highland Park.

A. J. GEBHARDT, Collector.
Office at Highland Park.
P. O. Address: New Brunswick, N. J.

made up as follows:

Poor	$25.00
Fire Dept. & Water	800.00
Streets, Ashes and Garbage	1,200.00
Lighting Streets & Public Places ...	1,400.00
Board of Health ...	50.00
Printing & Station'y	100.00
Salaries of Officers.	575.00
Interest & Discount.	500.00
Gen. Incidentals ...	200.00
	$4,850.00
Less License Fees, Franchise Tax and Other Sources ...	900.00
	$3,950.00
Added, by Resolu'n.	150.00
Total......$4,100.00	

AMOUNT	116
......MO INTEREST...	
COSTS	

Dec 2 1908

Received payment

A. J. Gebhard

Bill No. Collector.

TAX BILL FROM 1908. D.D. Skidmore ran a sanitary ice business at 9 North Second Avenue, and his property was assessed at $75. In 1908, his tax bill came to $1.16. The entire town budget is included on the bill so taxpayers knew how their tax dollars would be spent. Grocer Anthony J. Gebhardt was also Highland Park's longtime tax collector.

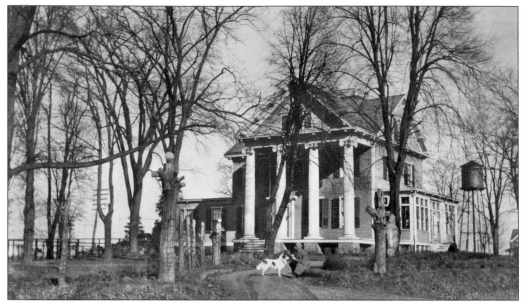

LIVINGSTON HOMESTEAD, C. 1907. Also called the Waldron House, this mid-19th-century house is one of only a few remaining riverview estate houses in Highland Park. It is listed in the New Jersey and National Registers of Historic Places. Built in the 1840s as a Livingston family summer retreat, it was modified in 1907 by Watson Whittlesey, creator of the north side's Livingston Manor neighborhood. It was the Waldron family home from 1909 to 1999.

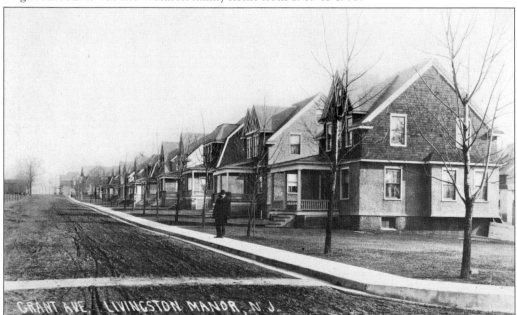

FIRST GRANT AVENUE HOUSES, C. 1906. The first row of houses built in the Livingston Manor neighborhood is located on the south side of Grant Avenue between Lawrence and North Second Avenues. Newspaper articles from September 1906 noted the change from the farmland of the Livingston estate to a suburban housing development. Whittlesey's historic planned residential neighborhood is bounded by River Road, Lawrence Avenue, Madison Avenue, and Cleveland Avenue. These houses were ready for occupancy by December 1906.

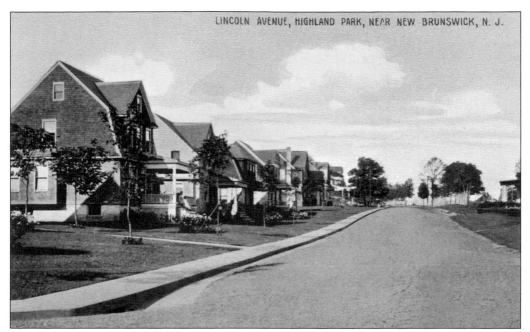

FIRST LINCOLN AVENUE HOUSES. This picture postcard shows the first row of houses constructed on the north side of Lincoln Avenue in the Livingston Manor neighborhood in 1907. They are located just west of North Second Avenue and originally faced Livingston Manor's playground and athletic fields.

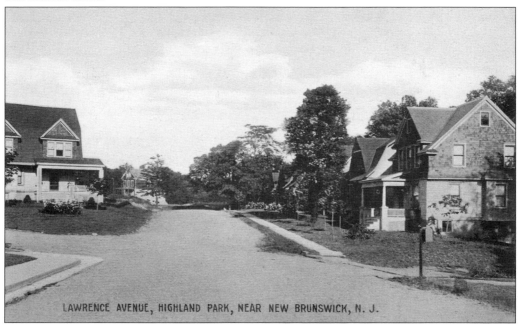

LAWRENCE AVENUE HOUSES. In some cases, the roads in Livingston Manor were not paved until the 1930s. Here, the intersection of Lawrence and Lincoln Avenues shows the concrete sidewalks and gutters that Whittlesey provided as part of his development. The neighborhood was listed in both the New Jersey and National Registers of Historic Places in 2004, signifying it as an important component of the borough's early development.

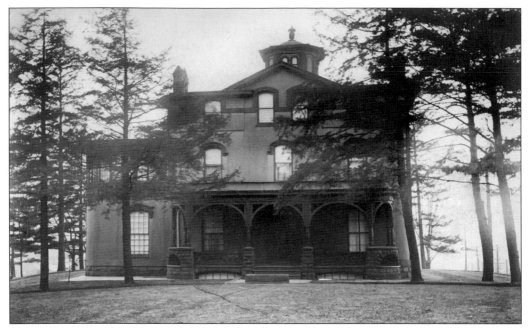

MEYER-RICE MANSION. This is the Adelaide Avenue side of the Italianate mansion that formerly stood at the head of South Adelaide Avenue overlooking the Raritan River. Built around 1855 by William Flagg, it was the residence of many prominent families, including the Meyers and Rices. It remained a private residence until the 1950s, when it was converted into the Jewish Community Center and Young Men's Hebrew Association. This sturdy stucco building was demolished in 2009.

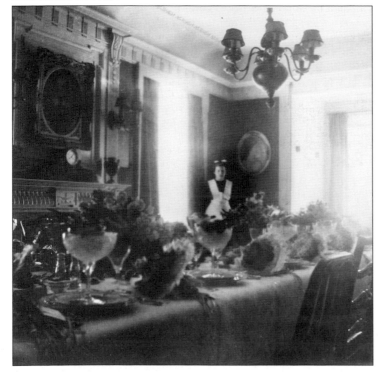

MEYER-RICE HOUSE DINING ROOM, JUNE 3, 1908. A maid stands ready to serve at a wedding reception at the Meyer-Rice house. Margaretta Meyer was a happy June bride when she married J. Kearney Rice Jr. According to an article in the *New Brunswick Times*, the dining room tables were decorated with roses and marguerites (a type of chrysanthemum) in honor of the bride's first name.

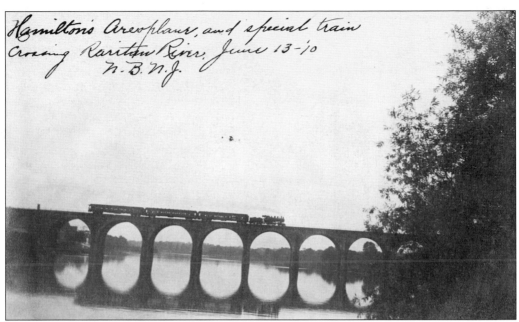

Hamilton's Aeroplane, and special train Crossing Raritan River, June 13-'10 N.B.N.J.

HAMILTON'S HISTORIC FLIGHT ON JUNE 13, 1910. Local photographer Isaac Van Derveer took this wonderful photograph (above) of Charles K. Hamilton's aeroplane as he made his maiden flight over the skies of New Jersey in 1910. Hamilton flew his canvas-and-metal contraption from New York to Philadelphia and back. Newspapers in both cities sponsored the trip. Hamilton followed the path of the Pennsylvania Railroad tracks while a special train carrying dignitaries steamed along underneath. The tiny airplane is nearly invisible in the center of the photograph. No wonder Lewis Hoagland made a facsimile (below) to commemorate the event. Hoagland's postcard combined a close-up image of Hamilton's aeroplane superimposed onto an everyday view of the Raritan River and the Highland Park riverbank seen from the Albany Street Bridge. It is one in a set of 16 picture postcards he produced in 1910.

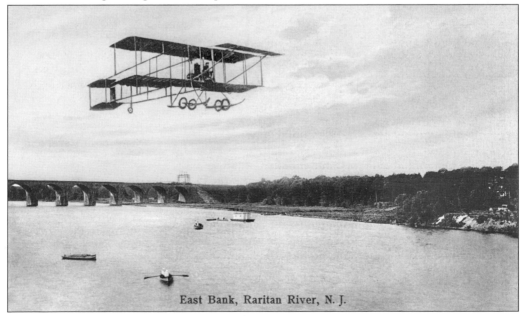

East Bank, Raritan River, N. J.

19

Adelaide Avenue,
Highland Park, N.J.

SOUTH ADELAIDE AVENUE. One of the oldest streets in Highland Park, Adelaide Avenue was established in the 1850s, and several mansions were built on the west side overlooking the Raritan River. Those estate lands have been filled by apartment complexes and housing developments throughout the 20th century. The houses on the east side of the street, seen in the 1910 Hoagland postcard above, include a few that were built in the second half of the 19th century. The Jacqui-Kuhn Funeral Home (below) is located at 17 South Adelaide Avenue. It was originally built as a Second Empire–style residence, and James Archer, the first mayor, was residing here in 1905. The house was converted into a funeral parlor in 1949 by William H. Jaqui. After Jaqui's son-in-law James A. Kuhn became owner in the early 1970s, the name was changed to combine the two last names. The Potts family has operated the business since 1995, retaining its historic name. (Below, courtesy of Ruth Jansyn.)

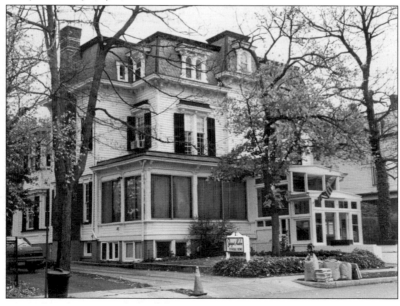

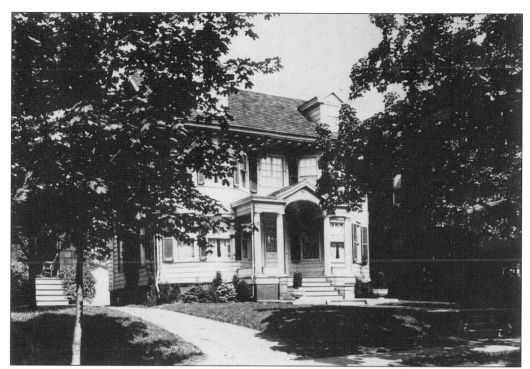

LOCAL ARCHITECT ALEXANDER MERCHANT (1872–1952). The house on South Adelaide Avenue shown here was built by Alexander Merchant in 1908. Merchant was one of central New Jersey's most prolific architects from 1897 to 1952. He designed over 20 important schools and residential and commercial buildings in Highland Park alone. His granddaughter Jeanne Liebenberg loaned these two photographs, and the portrait shows Merchant and his wife, Margaret, in their later years at an unidentified location. After building his own house, other Highland Parkers commissioned him to design houses for them and became his new neighbors. A few houses on Cliff Court and South Adelaide Avenue have been identified as Merchant designs based on plans included in the Barrood Collection at the New Brunswick Free Public Library. Several of Merchant's Highland Park buildings are portrayed on the following pages.

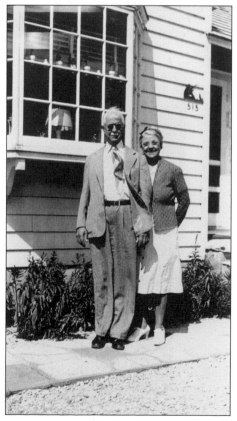

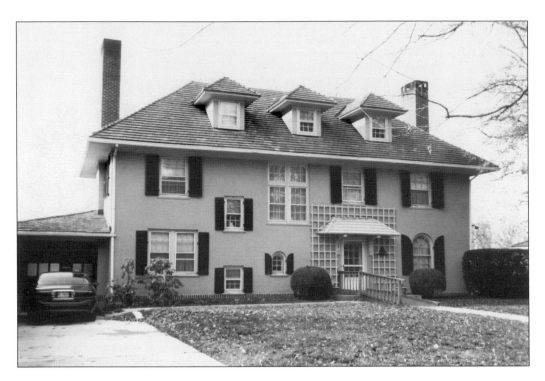

TWO ALEXANDER MERCHANT HOUSES. The stucco house on Cliff Court, with its irregular pattern of windows (above), was an unusual design for Alexander Merchant, who was known for his symmetrical facades. Whoever commissioned the architect must have had very strong influence to make him deviate from his classical architectural vocabulary. The stucco and terra-cotta tile house on South Adelaide Avenue (below) shows more of Merchant's typical design work, which included regular fenestration and ornate entranceways.

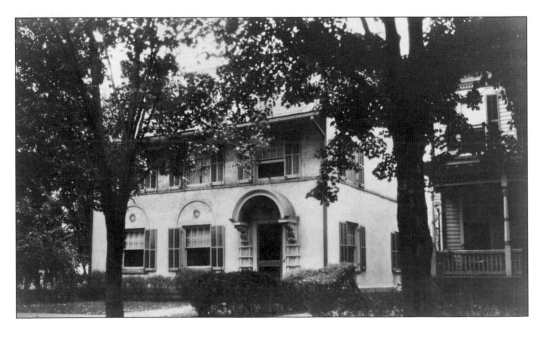

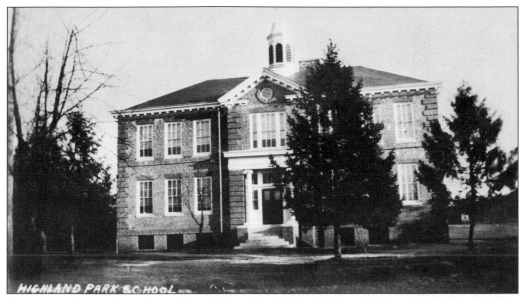

LAFAYETTE SCHOOL, BUILT IN 1907. Alexander Merchant designed this school after voters in 1905 agreed to a special bond of $15,000 for its construction. The Highland Park School, as it was originally called, had four large classrooms, two cloakrooms, and a boardroom. Rooms built extending the original 1886 school on the same lot at the corner of Benner Street and South Second Avenue became the back rooms of the new brick school. The school opened on December 12, 1907. It was renamed Lafayette in 1915, when it received an addition (also designed by Merchant) on its South Second Avenue side.

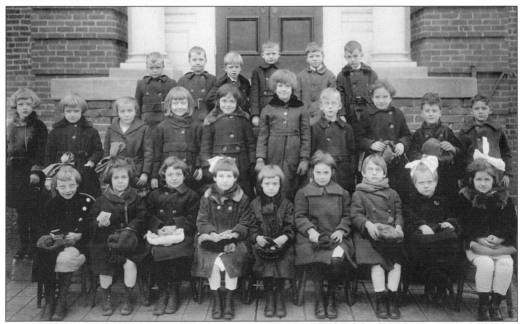

LAFAYETTE SCHOOL GROUP PORTRAIT. Written on the back of the mat board are the name Loring Willis and the date December 1920. This shows a younger grade at Lafayette School, perhaps third or fourth grade. By 1916, Highland Park had three neighborhood schools: Lafayette on the south side, Hamilton on the north side, and Irving in the "Triangle."

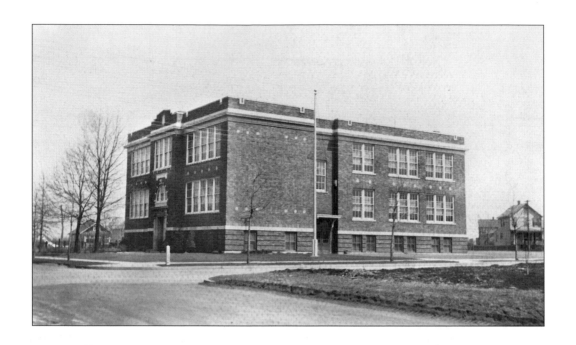

ARCHITECTURAL TWINS, IRVING AND HAMILTON SCHOOLS. These two buildings were constructed during the years 1915 and 1916. Alexander Merchant was commissioned to design one set of plans that were to be used to construct both buildings: Irving on Central Avenue at South Eleventh Avenue (above) and Hamilton on North Third Avenue near Lawrence Avenue (below). Merchant would also win the commission for a junior high school that would later become the Highland Park High School. His architectural legacy remains intact despite numerous additions constructed during the 20th century.

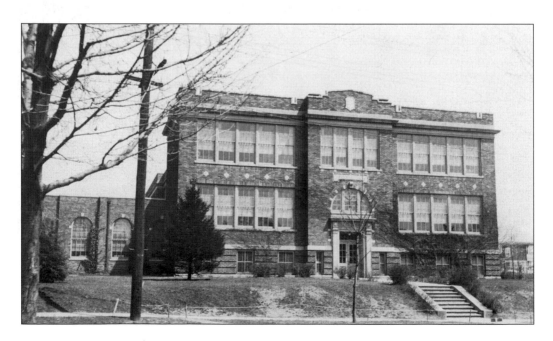

FACTORY TURNED INTO RESIDENCE. This one-story building on North Third Avenue at Wayne Street is an oddity in a neighborhood of taller dwellings. The 1912 Sanborn map indicates this was the Pembroke Process Company, producer of typewriter ribbons. The photograph, taken in 1933 by itinerate photographer J. Lloyd Grimstead, shows that the building had become a residence. Other such commercial ventures were integrated in neighborhoods before strict zoning began in the 1920s.

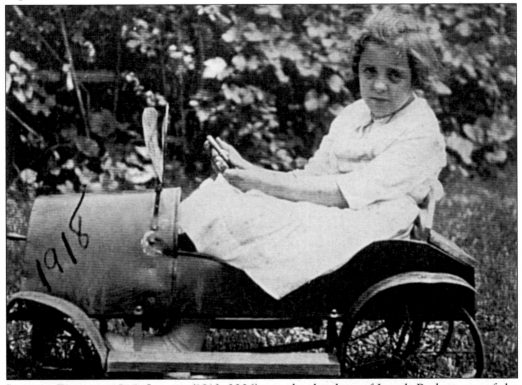

JUANITA BARLOW, 1918. Juanita (1910–2006) was the daughter of Joseph Barlow, one of the two druggists in town. Here she poses in her pedal car. She remembered helping her father by delivering prescriptions during the influenza epidemic in 1918. Making history as a 21-year-old, she became the first woman to graduate from Rutgers University School of Pharmacy in 1931. Very proud of her upbringing, she generously shared her own history and family photographs with the historical society.

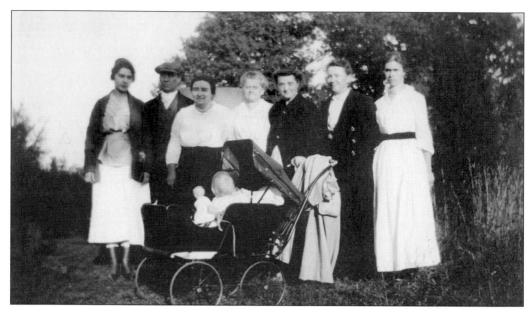

THE EDEN FAMILY, 1917. This photograph shows members of the Eden-Baier family on October 2, 1917. The family included Edwin W. Eden, who became mayor in 1928, and also Eleanor Eden Williams (1919–2011), best known as the co-owner of the Corner Confectionery from 1980 to 1992 and as a clerk at Saiff Drugs until 2006. Eleanor's older brother Edwin is the baby in the carriage.

VIEHMANN TRACT HOUSE. This house is located on North Fifth Avenue in a development financed by George Viehmann, a banker and mayor of New Brunswick. Beginning around 1910, many of these modest houses built with modern conveniences were constructed by the Highland Park Building Company. An advertisement from the March 17, 1917, *Daily Home News* shows three new Viehmann Tract houses were ready for purchase: for $4,600, $5,500, and $8,000.

Two

THROUGH YEARS OF WAR AND THE

GREAT DEPRESSION

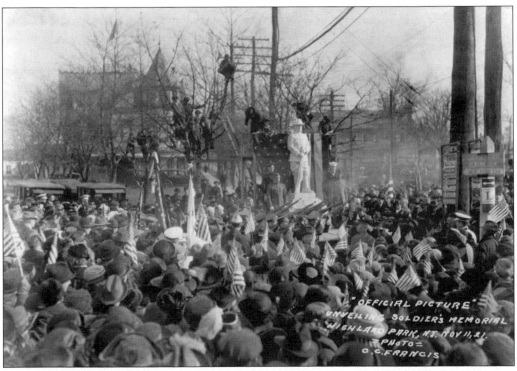

UNVEILING DOUGHBOY MEMORIAL STATUE. Highland Park's memorial to World War I veterans was produced at the L.L. Manning & Sons Company in Plainfield. Purchased with funds raised in door-to-door canvassing, it was erected in 1921. The grand unveiling took place after a lengthy parade closed Raritan Avenue for hours on Armistice Day, November 11. A brass plaque attached to the granite base reads, "A Memorial to Those Who in the Spirit of Self-Sacrifice Enrolled Themselves in the Service of Their Country in the World War 1914–1918, Highland Park, N.J."

Highland Park Will Supply 17 Men For New National Army

Highland Park will be called upon to furnish seventeen men for the new national army. In the draft lottery of last Friday seventeen Parkites fell within the first 296 numbers drawn that were held by men of the Second District of Middlesex county—296 being the quota for the Second District, of which Highland Park is a part. Some of the seventeen men may be exempt, however.

It is expected that the Exemption Board for the Second District, following the general practise throughout the country, will summon twice the number of men required to fill the district's quota. This will mean that 592 of the men registered in the Second District will receive notice to report to the Exemption Board, which is composed of Sheriff Houghton, County Clerk Gannon and County Physician Carroll.

In addition to the seventeen Parkites who came within the first 296 numbers in the Second District, thirty-five others are within the first 1,000 numbers drawn in that district. Highland Park men, in the order of their liability for service, are as follows:

Order No.	Serial No.	Name
17	2339	Andrew Jack, Jr.
46	2453	James A. Compton.
95	2455	Thomas A. Conway.
101	2374	Russell E. Thistle.
152	2319	Frank V. McCarthy.
154	2479	Holly Hall.
166	2441	Edward A. Brodell.
174	2330	John S. Mossop.
190	2390	James A. McG. Jack.
197	2322	Henry C. McWhorter.
207	2456	Charles F. Criss.
229	2438	John V. Bissett.
243	2397	Sam Kislin.
246	2414	George R. Loblein.
251	2467	Geo. F. K. Fasting.
257	2331	Clifton L. Mott.
274	2473	Charles R. Gildersleeve.
310	2360	Walter W. Smith.
324	2434	George Berleu.
341	2365	Harold R. Segoine.
363	2454	Edwin F. Conger.
378	2448	Harold T. T. Case.
387	2376	Clarence L. Timmons.
393	2396	Andrew Kirkpatrick.
434	2421	Oliver Askins.
439	2439	Edw. Blakeney.
448	2462	Harold W. Drake.
481	2458	Chas. W. Dowd.
534	2364	Frank Sczabo.
544	2406	Clifford Lee.
576	2476	Michael Gorney.
578	2405	John C. La Mens.
616	2370	Warren L. Taylor.
634	2430	John W. Bartlett.
670	2432	George W. Baxter.
675	2461	Guy R. Downer.
689	2342	F. F. Potter.
699	2485	Walter D. Heaphy.
717	2409	Duke S. Leonard.
739	2444	William J. Barcse.
740	2491	Roy F. Irvin.
766	2489	Harold A. Huestes.
810	2436	Russell J. Bergen.
813	2386	Carl R. Woodward.
846	2427	Harry L. Ballou.
859	2375	Wyatt R. Thistle.
868	2465	Calvin Ervin.
869	2480	William H. Hamilton.
879	2348	Archibald Rich.
931	2372	Chas. G. Kohlasch.
956	2345	Frank W. Reiter.
984	2325	Samuel W. MacMullen.

NEW NATIONAL ARMY, 1917. On July 20, 1917, in Washington, DC, selective conscription was put into effect and a national lottery fixed the order of military liability for the 10 million young Americans registered for service. A total of 10,500 numbers had to be drawn at one time, a task that began in the morning and lasted well into the night. The lottery drawing was conducted by war department officials in the Public Hearing Room of the Senate Office Building, witnessed by members of the Senate and House Military Committees. This *Daily Home News* article listed those young men from Highland Park who were likely to be drafted into military service.

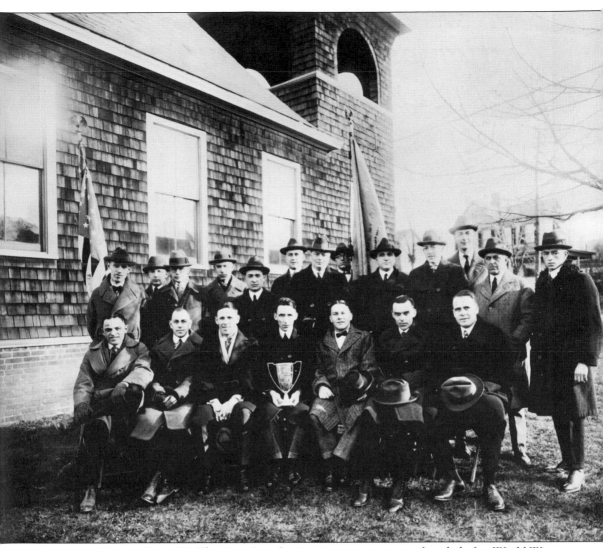

AMERICAN LEGION POST 88. The American Legion is a veterans group founded after World War I. A nonpartisan group, it never endorses candidates of any political party but lobbies on behalf of the veterans with particular emphasis on winning a "soldier's bonus" payment and alleviating unemployment. The founders of Highland Park Post 88 pose in this photograph taken November 26, 1922, on the lawn of the Baptist church at Raritan and Second Avenues. The shingled chapel has since been dramatically altered with a cladding of brick. John Hunter (first row, center) holds the cup awarded to this post by the Department of New Jersey, American Legion for the largest increase in membership statewide during 1922. From left to right are (first row) Theodore Anzolut, Russell Bergen, Fred Kobler, John Hunter, Joseph Edgar, Willard Yager, and Klemmer Kalteissen; (second row) Emil Brass, Jerome Van Nest, J. Ford Flagg, David Warfield, Sebastian Torrisi, George Wright, Nelson Dunham, Duke Leonard, Denton Brome, Christian Hansen, William Swain, Bayard Kirkpatrick, and Walter Eberlein.

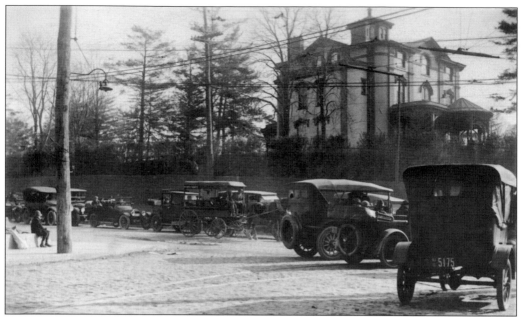

BUSY CROSSROADS, C. 1920. In 1914, Raritan Avenue became part of the Lincoln Highway, a transcontinental roadway from New York to California. The intersection of Raritan Avenue and River Road at the west end of the Albany Street Bridge was often crowded and chaotic. Diane Cucci provided this snapshot of a typical 1920s traffic jam under the dominating presence of the Meyer-Rice mansion. The first traffic signal was installed here in 1927.

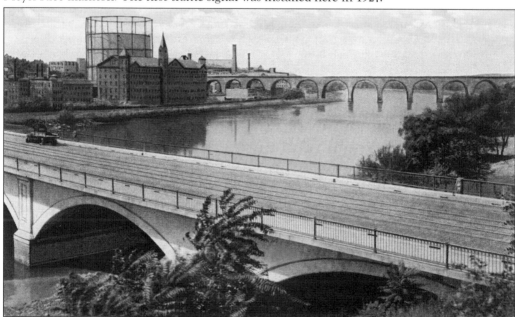

WIDER ALBANY STREET BRIDGE, 1925. This postcard shows the vital bridge linking Highland Park and New Brunswick. It was widened in 1925 with an additional lane and sidewalk on the south face. Unfortunately, poured concrete was used and the original stone obscured. The north face retains its 1893 stone face, which can be seen best from the Raritan River. The tall concrete wall on Raritan Avenue opposite River Road was built as part of the bridge-widening project.

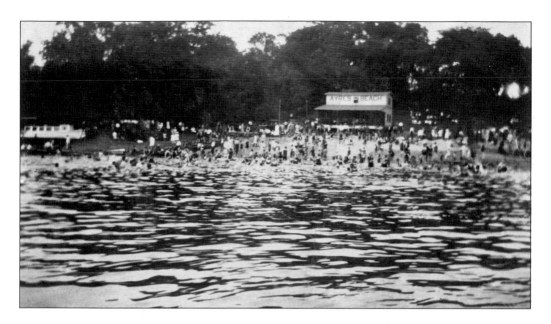

AYRES BEACH ON THE RARITAN, C. 1920. Many longtime residents remember Ayres Beach. Fred Klein wrote, "my family swam there until sometime in the mid 1920s and went to the boat house after that for a few years." Despite it being sited on a polluted river, Frank Ayres created a beach with several truckloads of white sand. He also served a variety of snack foods out of the beach house. The postcard view (below) shows this stretch of calm water being used as a boat basin. In 1939, a small allotment of Works Progress Administration funds paid for paving the road to the beach. Middlesex County petitioned for more funds to establish Ayres Beach Park, but they were not granted. In 1940, Ward Freese saved the life of a drowning eight-year-old. Ayres continued to run his waterside park until his death in 1945.

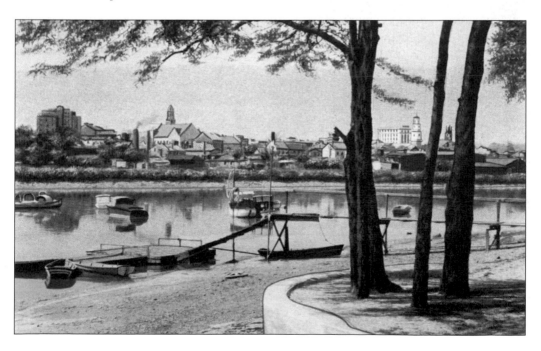

New Brunswick Knitting Co.

BATHING SUITS

A full assortment of Men's, Women's and Children's all in pure wool, ranging in price from $1.00 to $7.00, for imperfect and perfect suits, in a full range of oclors and sizes up to outsize 52.

RAYON LINGERIE

We are now selling at the factory Fibre Silk Lingerie. This can be had in vests, step-ins, and bloomers in an exceptionally fine quality cloth, in fll range of colors and sizes up particularly good.

New Brunswick Knitting Co.
431 RARITAN AVENUE **HIGHLAND PARK, N. J.**

KNITTING COMPANY GOODS, 1925. This advertisement for locally made factory goods was in the *Daily Home News* on June 13, 1925. Many swimmers at Ayres Beach probably wore New Brunswick Knitting Company swimsuits. DeWitt B. Strauss and Daniel Rheinaner founded the New Brunswick Knitting Company in 1919 at 431 Raritan Avenue and expanded to 429 Raritan Avenue. By 1930, the name changed to the Acme Underwear Company, and it continued operating until 1950. Longtime residents remember buying their undergarments there.

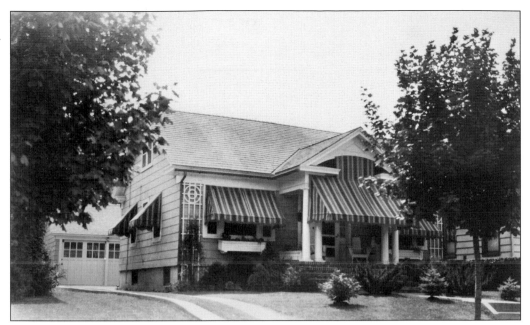

SEARS, ROEBUCK AND COMPANY KIT HOUSE. The one-story house at 308 Harrison Avenue is a nice example of "The Crescent." This five-room house with its inviting front porch first appeared in the 1921 catalog. Sears produced its houses in pieces ready to be assembled, shipping them in boxcars to customers countrywide. Ruth and Leon Jansyn identified other Sears kit houses at 402 Grant, 216 and 325 Felton, and 323 Harrison Avenues.

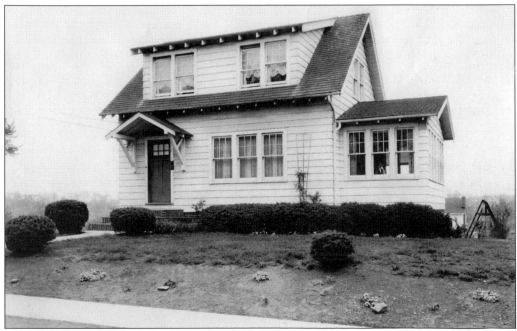

LOIZEAUX PLAN BOOK HOUSE. As an important part of the 1920s small house movement, the Loizeaux Company based in Plainfield was one of many that sold ready-made architectural house plans to individuals and builders. This Donaldson Street house with six rooms plus sunroom and bathroom is identical to Plan 12628-B from Loizeaux's (1927) Plan Book No. 7.

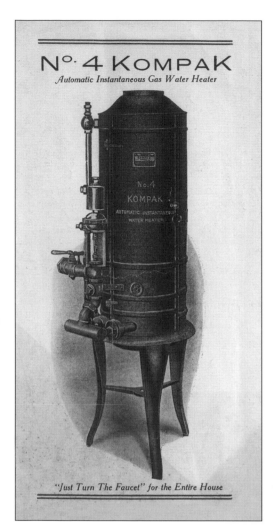

Nº. 4 KOMPAK
Automatic Instantaneous Gas Water Heater

No. 4
KOMPAK
AUTOMATIC INSTANTANEOUS
WATER HEATER

"Just Turn The Faucet" for the Entire House

KOMPAK AUTOMATIC STORAGE GAS WATER HEATER. All these new houses were built with the latest modern conveniences, including water heaters. Founded in 1908 by Herbert James Long, the local business grew from a small operation in a barn to become the Kompak Company, located at a factory at 226 Cleveland Avenue in 1919. Named after its most successful product, the Kompak Gas Water Heater, by 1920, the company raked in $600,000, which was triple the earnings of the year before.

Interior View

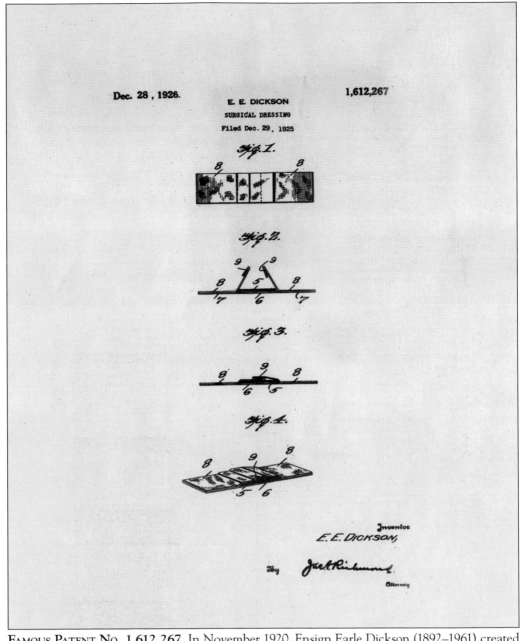

Dec. 28 , 1926.

E. E. DICKSON

SURGICAL DRESSING

Filed Dec. 29 , 1925

1,612,267

Fig. 1.

Fig. 2.

Fig. 3.

Fig. 4.

Inventor

E. E. DICKSON,

By Jack Richmond

Attorney

FAMOUS PATENT NO. 1,612,267. In November 1920, Ensign Earle Dickson (1892–1961) created the prototype of Johnson & Johnson's best known product, the Band-Aid. Dickson resided at 326 Montgomery Street with his wife, Josephine, and created premade bandages for her to use after her kitchen mishaps, for which she became well known. Johnson & Johnson management took Dickson's idea and began producing these handy items, first by hand and later by machine. By 1926, Dickson applied for a patent, not for the bandage itself, but for the interlocking flanges on the facing material (then crinoline) that made each Band-Aid easier to open. This is the illustration that accompanied his patent application. Dickson's career at Johnson & Johnson was long and successful. By the time he retired in 1957, sales of Band-Aids had reached the $30-million mark.

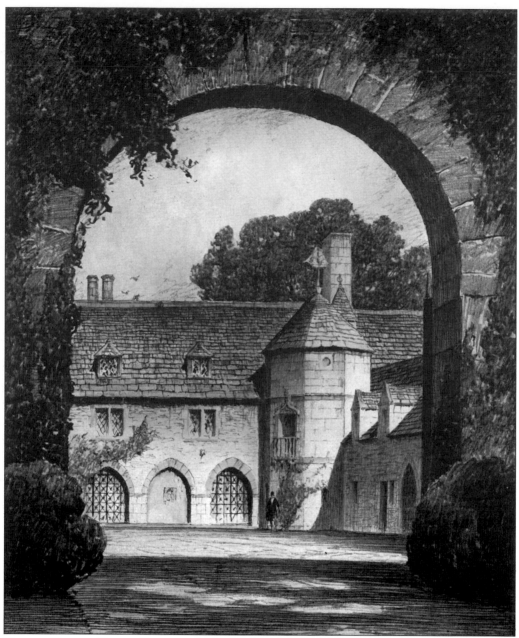

Thomas Harlan Ellett Designs a Castle. "The Castle," as it has become known, on River Road was constructed from 1924 to 1926. Its original name was Merriewold, meaning "merry wilderness," presumably due to the forest covering the large parcel of riverview land making up J. Seward Johnson's estate. A member of the family running Johnson & Johnson, Seward Johnson hired New York architect Thomas H. Ellett (1880–1951) to design an English Collegiate Gothic–style estate house. Ellett had a reputation for designing many distinctive country estates, and Johnson entrusted him to incorporate over 500 tons of roof slates imported from the Cotswold region of England. The main structure was built using stone blocks from Pennsylvania. The forecourt was illustrated by Charles Price for the August 1926 edition of *The Architect*. In 1928, Ellett won the New York Architectural League's silver medal for Merriewold's design.

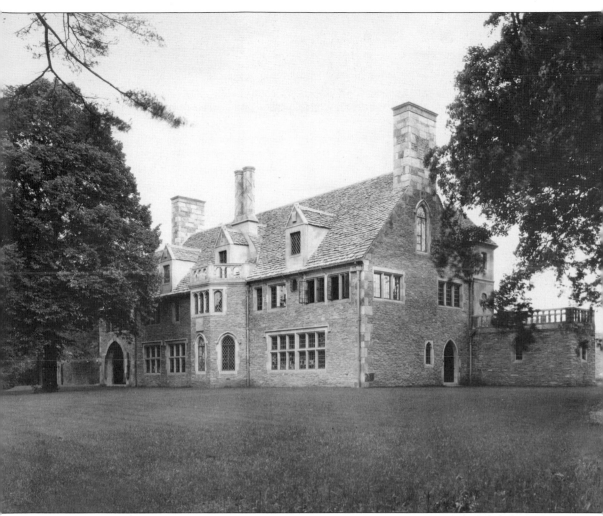

THE CASTLE OVER THE YEARS. This 1932 photograph shows The Castle's River Road facade. This 25-room mansion was built for J. Seward, his wife, Ruth, and their four children, but they only lived there together for 10 years. In 1945, the main house became a nursing home, and later, it was home to Charles and Barbara Farmer, until Barbara's murder at the hands of her insane husband in 1963. Since 1968, the mansion, the outbuildings, and the land have been the business center of Kaplan and Sons Construction Company. The Kaplans recently added a new wing in the style of the original castle.

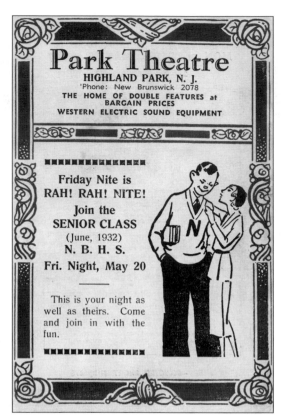

PARK THEATRE, 1932. In the years between 1927 and 1961, Highland Park had a movie theater located on Woodbridge Avenue at South Sixth Avenue. The block-wide Art Deco theater could seat 1,400 people. On November 21, 1927, dignitaries attended the opening day film *Clancy's Kosher Wedding*. The historical society does not have an image of the entire building, although it has several programs. This one is from a special event held for high school seniors in 1932.

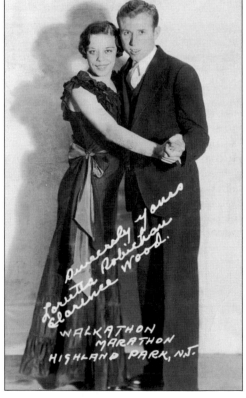

DEPRESSION-ERA AMUSEMENTS. Loretta Robichou and Clarence Wood participated in the Walkathon Marathon held at the Masonic Temple auditorium some time in the early 1930s. Walkathons were tests of endurance in which adult couples were on their feet 24 hours a day with only 10 minutes of rest every hour. Spectators cheered for their favorites, albeit from the comfort of seats.

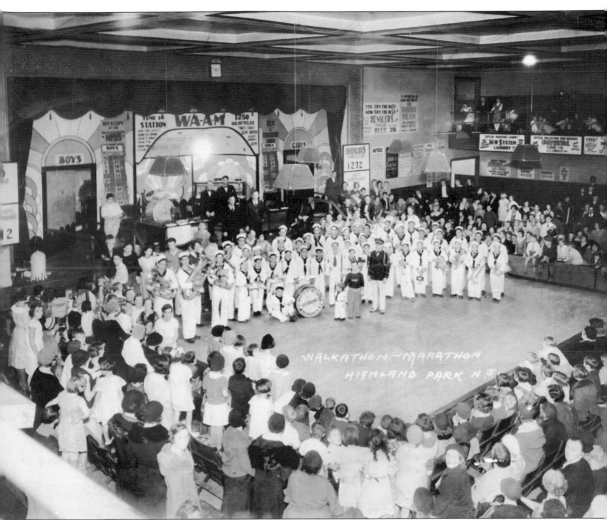

INSIDE THE MASONIC TEMPLE, C. 1932. This rare photograph of a Walkathon Marathon in Highland Park has no accompanying information. Using the radio station's call letters WAAM, it was determined that this event took place around 1932. The Masonic Temple was the only building in town large enough to hold such an event. Designed by Alexander Merchant, the building was under construction from 1922 to 1923, opening on September 17, 1923. It became the borough's community center. From that time until a dramatic fire in 1965, sporting events, indoor circuses, dances, and concerts took place in the spacious auditorium.

JAMES LLOYD GRIMSTEAD'S HOUSE PORTRAITS. This borough became very fortunate when, in 1933, a photographer based in Metuchen spent several days photographing 600 Highland Park houses. Grimstead made his living during the Great Depression by selling postcard house portraits to proud homeowners. In the photograph above, he captured two ladies returning home or visiting 82 Harrison Avenue, the home of J.T. Duffy, in 1933. In the photograph below, not only were the residents at 511 South First Avenue house-proud, they were also children-proud. Here, their youngsters posed for Grimstead in their best clothes and with their pets in the yard.

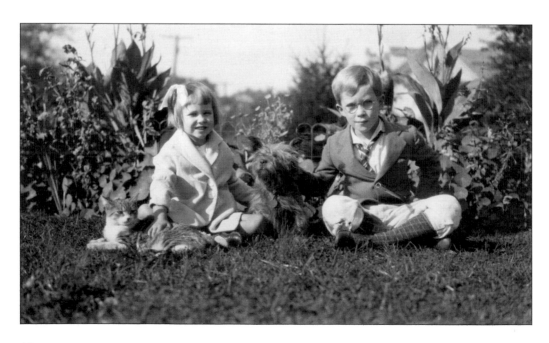

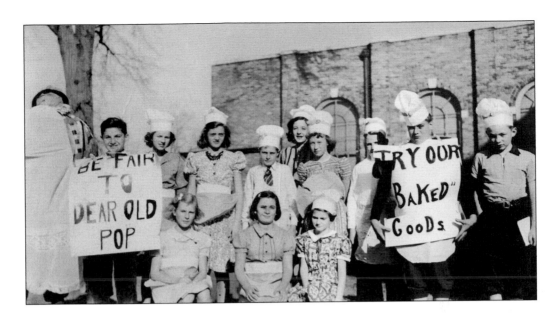

TREASURE TROVE OF PTA PUBLICITY BOOKS. Beginning in the 1930s, the Highland Park school Parent Teacher Associations (PTA) started creating publicity books that included press clippings, photographs, and newsletters. These were fortuitously saved and donated to the historical society. The photograph above shows a group of unidentified Hamilton school students cleverly advertising a bake sale held on November 15, 1939. The advertising (below) for a card party sponsored by the Lafayette School PTA shows a price reduction of 5¢. Other events (beside bake sales) sponsored by these advocacy groups included annual flower shows (at Lafayette School), strawberry festivals, and lectures.

LAFAYETTE P. T. A.
HIGHLAND PARK, N.J.

CARD PARTY

WEDNESDAY, DECEMBER 7, 1932 AT 2:00 P.M.

——— AT ———

KOOS BROS.
DIRECT-SAVING FURNITURE CO.

ST. GEORGE AVENUE. RAHWAY, N. J.
NEXT TO FRANKLIN SCHOOL

PRIZES & REFRESHMENTS — TICKETS 50 CENTS

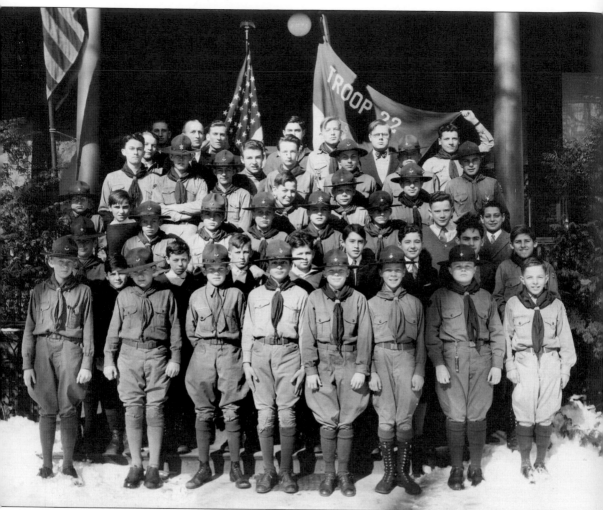

BOY SCOUT TROOP 22. Highland Park supported two Boy Scout troops beginning with the establishment of Troop 2 in 1912 and Troop 22 in 1923. When Troop 22 was brand new and in a recruitment drive, Nelson Connors led a knot-tying demonstration followed by a hike. The new recruits were treated with a hot dog roast. The boys in this c. 1937 photograph are unidentified. The location is in front of American Legion headquarters at 127 Benner Street. The boys learned first aid, knot-tying, and camping skills and marched with the American Legion in parades.

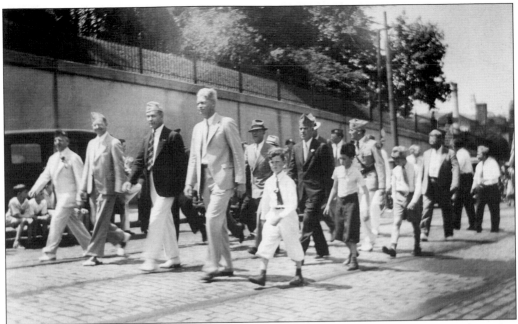

MEMORIAL DAY PARADE, 1937. The American Legion was able to save only a small portion of its archives after a devastating flood at the headquarters around 1999. Frank Conover Sr. donated several items to the historical society in 2005. This slightly blurry parade photograph does not have the participants identified, but it notes that it is Post 88 marching up Raritan Avenue.

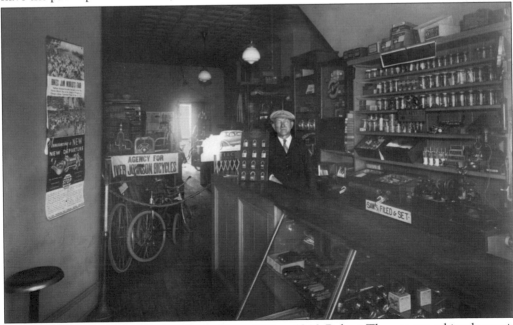

ROBERT L. THOMAS BIKE REPAIR SHOP. From 1924 to 1946, Robert Thomas ran a bicycle repair shop at two locations in town. First located at 3 Raritan Avenue in a building that no longer exists, he moved his business to 125 Raritan Avenue in 1937. This undated photograph donated by his granddaughter Diane Cucci shows Thomas surrounded by every spare part a bicyclist would need.

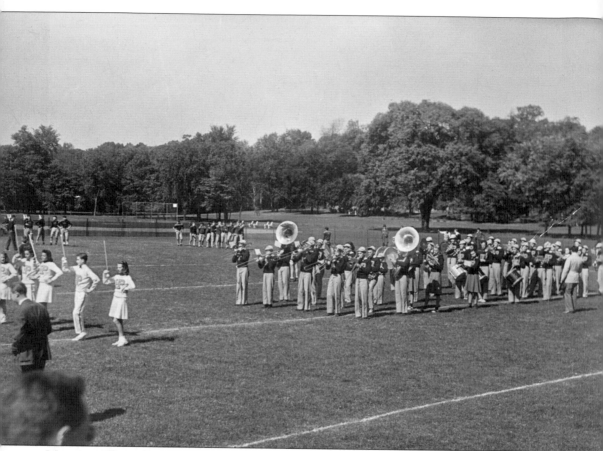

MARCHING BAND PERFORMANCE. The full four-year program at Highland Park High School was only two years old when this photograph was taken. Until 1938, junior high students had to finish their high school careers either in New Brunswick or at other nearby high schools. This photograph from the October 25, 1940, edition of the *Highland Fling* shows the uniformed Highland Park High School band and baton twirlers performing at a football game. Connie Atkinson Jr. was band director from 1940 until 1955, when his son Connie Atkinson III took over as music director.

Three

WORLD WAR II AND THE MODERN MID-CENTURY DECADES

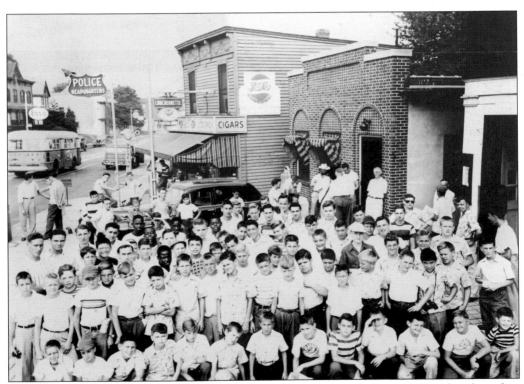

TAKE ME OUT TO THE BALL GAME. On July 27, 1949, baseball enthusiasts gathered at the police station to board the bus for a Policeman's Benevolent Association–sponsored baseball game between the New York Yankees and the Cleveland Indians. The buildings seen in this photograph are the firehouse (a partial view on the far right) the one-story police station designed in 1925 by Alexander Merchant (middle), and a building constructed in 1895 as a candy store (left). In the 1920s, the candy store became William Himelstein's confectionery; by 1948, it had become Lawrence Hoffman's confectionery.

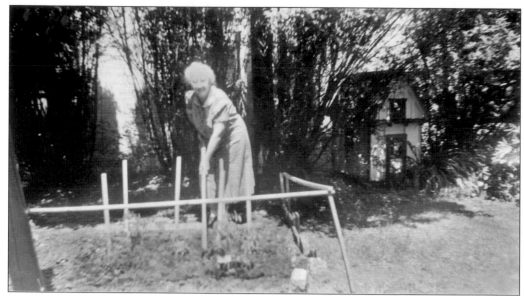

THE HOME FRONT DURING WORLD WAR II. Lois Lebbing donated a photograph album that had many snapshots taken at 315 Harrison Avenue by the Alf F. Knobel family during the war years, 1941 to 1945. Knobel was listed in the city directory as a clerk at Tar Asphalt Service, Inc. Pictured here is Caroline Knobel tending her Victory Garden. The town also took austerity measures, organized scrap drives, rationed gasoline, and conducted air raid drills for the duration of the war.

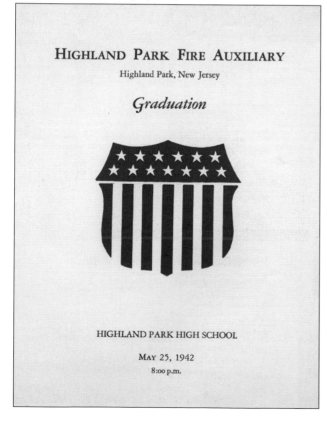

HIGHLAND PARK FIRE AUXILIARY. In 2003, the John and Dot Cost papers were fortuitously saved from recycling bins. John Cost, a New York Telephone Company safety officer, became an active member of the town's 1940s civil defense efforts. This program lists the names of 39 new Fire Auxiliary members, who would hold air raid drills in order to be prepared in the event of attack. A government-issued truck was stored in Cost's garage on North Fourth Avenue.

[July 24, 1943] Sat. morning 7:45

Dearest Lil —

This is yours truly again.
Last night attended the boxing matches
in camp. Pretty good. Also had some wrestling.
Jimmy Durante put in an appearance with
some jokes. He had been in a show held
in camp that night.
I hope all is well with you. And
that you enjoy yourself with your parents
at the beach this week end.

A Soldier's Letter Home. The historical society has 47 letters sent in 1943 to Lillian Jacobson from her husband, David, a soldier in the US Army. Here he tells his wife that he heard Jimmy Durante tell some jokes the night before. Jacobson was one of the lucky ones who made it safely home. His is not one of the names listed on the plaque dedicated to Highland Park's war dead in Veterans Memorial Park at the intersection of Woodbridge and Raritan Avenues.

Red Cross War Fund Sticker. In 1944, how many proud Highland Park homeowners displayed such a sticker in their windows? This one was carefully removed and stored at the John and Dot Cost house for 60 years. The Red Cross operations during the first two years of the war were small by comparison to other events in the entire world during 1943. An even greater burden was placed on Red Cross services in 1944.

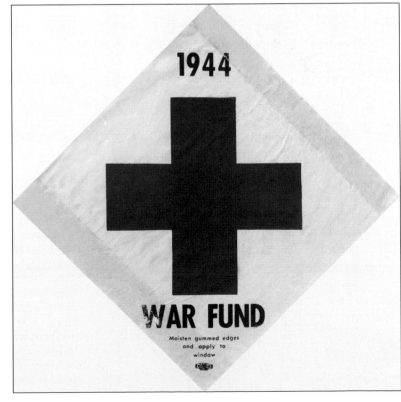

1944

WAR FUND

Moisten gummed edges
and apply to
window

STATE OF NEW JERSEY

OFFICIAL AIR RAID SIGNALS

From the time you FIRST HEAR SIRENS
KEEP LIGHTS OUT until you hear ALL CLEAR

A LONG STEADY BLAST IS THE **BLUE SIGNAL** MEANS PLANES APPROACHING	**DO THIS**	Turn OFF LIGHTS in Homes, Stores, Offices Pedestrians and Traffic may continue to move Street Lights Remain On Turn Radio On Don't Use Phone
A FLUCTUATING OR INTERMITTENT BLAST IS THE **RED SIGNAL** MEANS PLANES OVERHEAD	**DO THIS**	ALL LIGHTS OUT All Traffic Stops Stay Inside—If Outside, Seek Shelter Turn Off Gas Burners—But not Pilot Light Keep Radio On Don't Use Phone
A LONG STEADY BLAST (ALWAYS FOLLOWS RED) IS THE **BLUE SIGNAL** MEANS PLANES MAY RETURN	**DO THIS**	DON'T Turn On Lights even tho Street Lights Go On Pedestrians and Traffic May Proceed with Caution Keep Radio On (You'll need it for All Clear) Don't use Phone
ALL CLEAR WILL BE ANNOUNCED TO HOUSEHOLDERS BY **RADIO**	**DO THIS**	Turn On Lights — Blackout Ended A single short blast will notify Protective Forces of ALL CLEAR

WHAT TO DO IN THE EVENT OF A GAS ATTACK

1. KEEP CALM—A gas bomb will not poison a whole city block—you can always escape.

2. ALL bursting bombs SMELL, whether they contain war gas or not. Get away from the odor.

3. If INDOORS, stay there. Go upstairs. Close doors, windows, stuff wet towels into large cracks.

4. If OUTDOORS, hold your breath as long as possible. Get out of danger zone. HOLD A WET HANDKERCHIEF TO YOUR MOUTH.
There are two kinds of gas.

5. CHOKING GAS is GONE in 15 minutes. Do not rub eyes. If throat burns, wash with water. LIE ABSOLUTELY STILL UNTIL DOCTOR ARRIVES. Quiet drives gas from lungs. NO STIMULANTS.

6. The other is BLISTER GAS. It lasts longer. STINGS skin, nose, eyes. Get away from it. TIME IS IMPORTANT. Remove affected clothing and place outside. WITHIN FIVE MINUTES lather skin and hair with old-fashioned yellow laundry soap, rinse with lots of water. RUN WATER ON EYES. TIME IS IMPORTANT: IMMEDIATE SELF-AID with water prevents blisters. WASH AT ONCE. Then call doctor. DO NOT BREAK BLISTERS.

Your Air Raid Wardens Are

Name *Mrs. M.A. Chaffee* Street *353 N⁴ʰ 4ᵀᴴ Ave.*

Name *Mr. Jack Brower* Street *357 N⁴ʰ 4ᵀᴴ Ave.*

Your Block Leader Is

Name *Stuart S. Dreier* Street *335 N. 4ᵗʰ Ave.*

CONSULT YOUR BLOCK LEADER FOR INFORMATION ON—VICTORY GARDENS—NUTRITION—CANNING—HEALTH AND WELFARE—CHILD CARE—CONSUMER INFORMATION—RECREATION, SALVAGE AND OTHER WAR ACTIVITIES

By order of Governor Charles Edison this card is to be placed on the kitchen wall nearest the dining room or living room door for the duration. Must also be displayed prominently in stores, offices and public places.

E 153673

Leonard Dreyfuss
Civilian Defense Director.

SCOTT PRINTING CO.
JERSEY CITY, N. J.

OFFICIAL AIR RAID SIGNAL CHART. By order of Gov. Charles Edison, this chart was to be placed on the kitchen wall nearest the dining room or living room door. As part of the John and Dot Cost papers, it's a reminder of how much effort went into organizing the home front during World War II. The Highland Park Defense Council under Director Fred A. Scheidig had departments covering security, fire, public information, welfare, water, demolition, and communication. During a 1976 interview, longtime resident and teacher Bus Lepine stated, "Air raid drills were a part of our life then just like fire drills are today."

WHY BOTHER TO COOK....

....when it is as cheap to eat out!
Everything is just as clean and carefully prepared, and as good quality as you would use in your own home. We buy only the best meats and vegetables and do our own baking. Dinner 75c. Supper 60c.

A TYPICAL MENU
75c Dinner

Soup or Fruit Cup
Roast Lamb
Fresh Vegetables
Salad
Pie Cake or Pudding
Coffee Tea or Milk

OUR SPECIAL DINNERS
Wed. - *Corned Beef and Cabbage* Sat. - *Baked Beans and Ham*
Sunday - *Roast Turkey*

Buff and Blue Restaurant
TELEPHONE 2729
204 Raritan Avenue, **Highland Park, N. J.**

BLOTTER ADVERTISEMENTS. As early as 1928, the Buff and Blue Restaurant was located at 204 Raritan Avenue. This ink blotter (above) was probably handed out free of charge to customers. In 1946, the restaurant was renamed the Buff and Blue Tea Room, indicating that this blotter was printed before that year. The blotter J. Ford Flagg advertised his printing services on (below) dates to 1945, the year in which the last war bond drive took place. By using the caricature of Uncle Sam to promote the bond drive, Flagg also showcased his abilities as a printer. Flagg had a very well-known name, as he was borough clerk for many years.

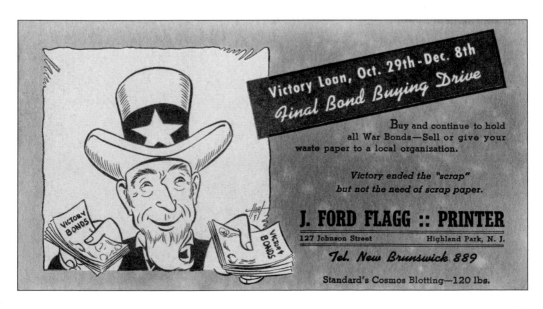

Victory Loan, Oct. 29th - Dec. 8th
Final Bond Buying Drive

Buy and continue to hold all War Bonds—Sell or give your waste paper to a local organization.

Victory ended the "scrap"
but not the need of scrap paper.

J. FORD FLAGG :: PRINTER
127 Johnson Street Highland Park, N. J.

Tel. New Brunswick 889

Standard's Cosmos Blotting—120 lbs.

JACOB FRANT'S PLUMBING BUSINESS. Starting his plumbing business in 1933, Jacob Frant continued working out of his house until retiring 40 years later. His daughter Bernice donated this business card from 1943 to the historical society. Frant was also the well-liked plumbing inspector for the borough for many years.

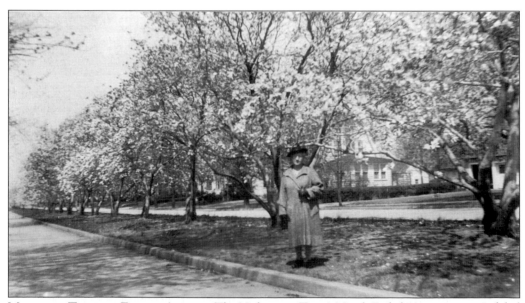

MAGNOLIA TREES ON EIGHTH AVENUE. The Viehmann Tract's North Eighth Avenue was modeled after broad boulevards with center medians. For many years, the median had rows of magnolia trees that were quite an attraction every spring. Here, Caroline Knobel poses on a fine spring day in the 1940s.

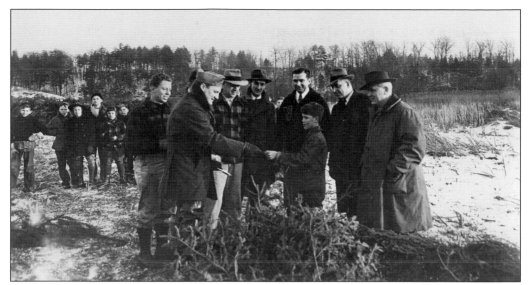

COLLECTING CHRISTMAS TREES, 1947. In January 1947, the borough sponsored a contest for local boys and girls to collect as many discarded "fire hazard" trees as possible and deliver them to the Meadows, adjacent to Donaldson Park. Prizes included a bicycle and a Boy Scout or Girl Scout uniform. Here, a participant receives his receipt. The collection of 1,500 trees resulted in a bonfire set at 8:00 p.m. on January 4 that lit up the valley.

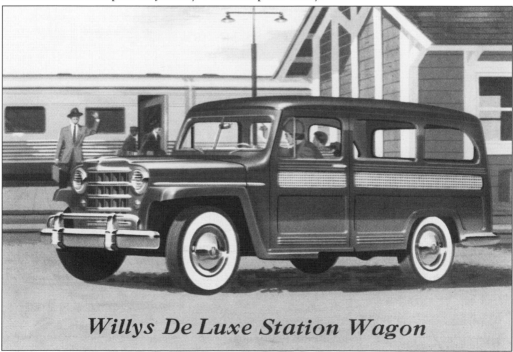

Willys De Luxe Station Wagon

WILLYS NEW BRUNSWICK, INC. "It's New . . . And It's Perfect For Pleasure or Business," according to the caption on the back of this postcard. Throughout the 20th century, Highland Park had many new car dealers and showrooms until the need for much larger lots drove them to the exurbs. This De Luxe station wagon was available for purchase at the Highland Park branch of Willys New Brunswick, Inc., at 712 Raritan Avenue.

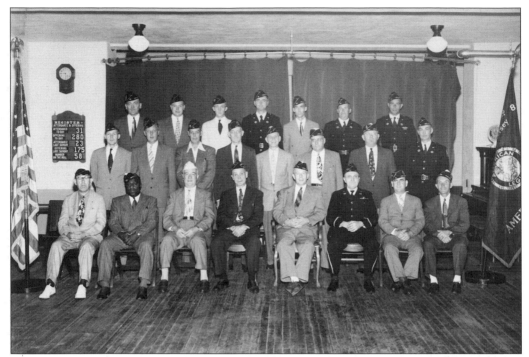

AMERICAN LEGION POST 88 PHOTOGRAPHS. These two photographs were from a small collection of items donated to the historical society when Post 88 sold its headquarters in 2002. The top photograph shows the new American Legion inductees at the installation on August 10, 1948. The photograph of the parade (below) dates to 1949. In the background are the two mansions that once flanked North Adelaide Avenue and overlooked the cobblestones of Raritan Avenue.

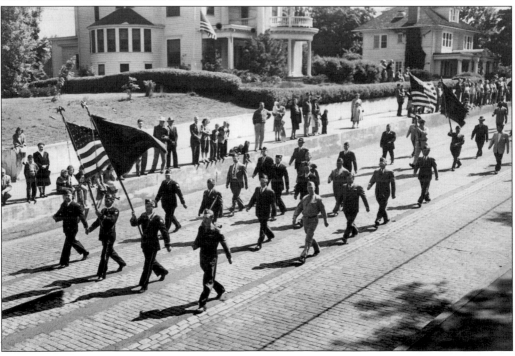

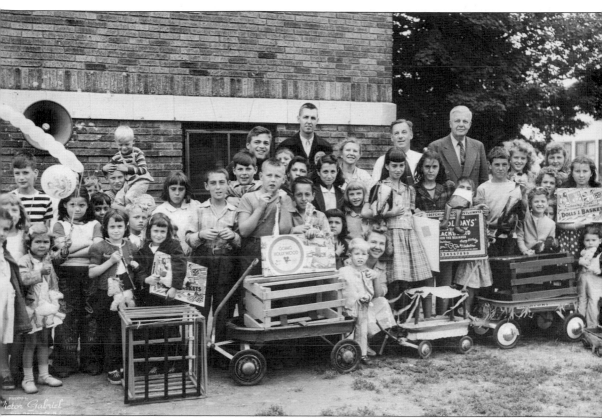

PRIZES AWARDED AT CIRCUS FETE. For many years, the borough has sponsored events as part of its summer recreation programs. This photograph from 1948, also on the cover, shows the children from the neighborhood of Irving School who, along with their stuffed animals, attended a circus party under the direction of playground supervisor Mary Fortna. Prizes were awarded for best horses, elephants, giraffes, bears, donkeys, lions, and seals. The adult judges standing at the rear of the group are, from left to right, Austin "Bus" Lepine, Mary Fortna, police captain Fred Scheidig, and Mayor Alvah H. Cole.

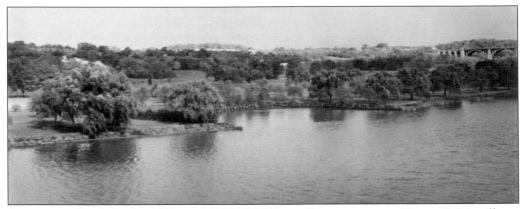

DONALDSON PARK. In the 1930s and 1940s, Middlesex County engineer George R. Merrill was an important park planner who created both Johnson and Roosevelt Parks. He drew proposals for the 70-acre Donaldson Park, the land having been purchased in 1936. Donaldson Park included a large circular drive with athletic fields in its interior. A stone-lined boat basin was also built, seen in this undated photograph looking northeast from New Brunswick.

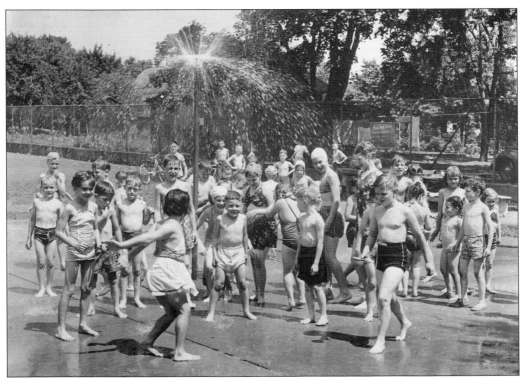

LAFAYETTE SCHOOL SUMMER SPRINKLER. Alice Boyce was the supervisor at the Lafayette School playground summer program, which included an outdoor sprinkler. Children from the neighborhood could escape the heat of a June day in 1948 by cavorting under the spray. Highland Park's highly admired summer recreation program was established by ordinance on July 7, 1947.

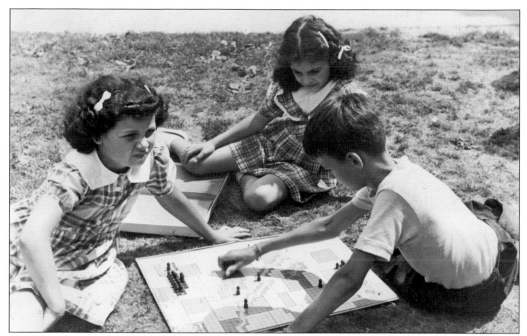

SUMMER FUN AND GAMES, 1948. Each of the playgrounds had board games such as carrom, checkers, and chess; materials for handicrafts; and equipment for horseshoe pitching, archery, badminton, volleyball, bowling, basketball, baseball, and softball. These children are playing Parcheesi at the Irving School playground.

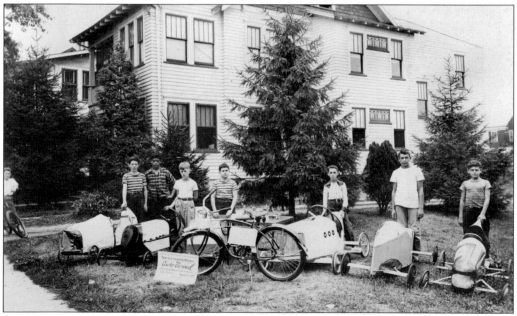

COASTER CARNIVAL, 1949. South Third Avenue was the scene of the first annual coaster carnival for soapbox derby racers. Sponsored by the borough as part of the summer recreation program, this event featured six coasters competing for the grand prize bicycle. Police chief Alfred Smalley was the official starter. Ted Toth of 323 Becker Street won top honors that day, beating out Morton Schwartz, Dante Orsini, John Schultz, Al Kvortek, and Ronald Parish.

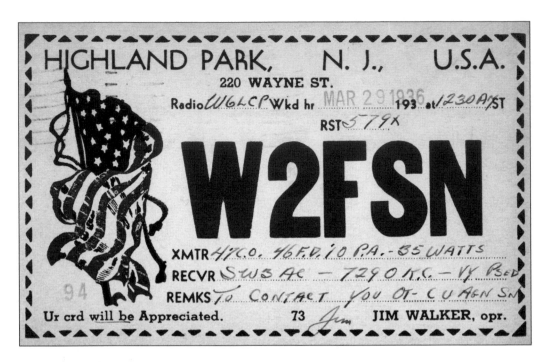

HIGHLAND PARK, N. J., U.S.A.
220 WAYNE ST.
Radio *W6LCP* Wkd hr MAR 29 1936 193 at *1230 A* ST
RST *579X*

W2FSN

XMTR *47C.O. 46 F.D. 10 P.A.-35 WATTS*
RECVR *SW3 AC — 7290 K.C. — VY PSED*
REMKS *To CONTACT YOU OT CU AGN SN*

Ur crd will be Appreciated. 73 *Jim* JIM WALKER, opr.

AMATEUR RADIO ENTHUSIASTS. In the 20th century, postcards were used for more than just sending greetings from vacation spots. They were also used for ordering groceries and arranging meetings. Beginning around 1916, radio enthusiasts sent each other Query Station Locator (QSL) cards, typically the size of postcards. QSL cards confirmed radio communication between two amateur radio stations or one-way reception from an AM radio, FM radio, television, or shortwave broadcasting station. These two QSL cards from ham radio operators in Highland Park date from 1936 (above) and 1964 (below).

Highland Park, N. J. 08904
308 Dennison Street

WB2IOX

Elaine Negran

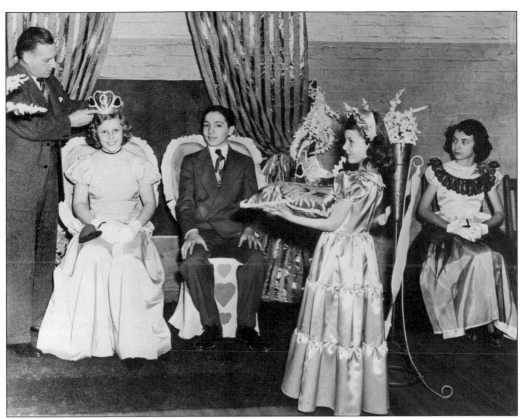

SWEETHEART DANCE, 1950. The recreation program had events year round. Over 100 youths attended the sweetheart party on February 11, 1950. The top photograph shows chairman Fred Scheidig crowning the Queen of Hearts, Betty Ann Zoller. Marshall Berman awaits his crown as King of Hearts. Carole Gilbert is seen bearing the King's crown on a satin pillow. The girl sitting at far right is unidentified. The photograph to the right shows some of the decorations that were made by a committee led by Alice Boyce. Boyce was director of the Junior Fling, a dance held at the recreation center in the basement of the Reformed church.

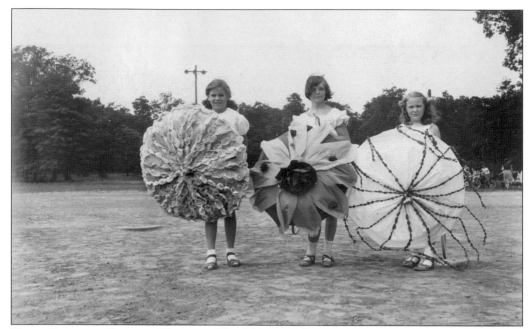

FANCY PARASOLS CONTEST WINNERS. The fifth annual Hyman Katz Day took place on July 20, 1950. Katz was the borough tax assessor and sponsored this annual party for many years. Winners of the fancy parasol contest are, from left to right, Joan Fiero (prettiest parasol), Patricia O'Keefe (most original parasol), and Ann Purvis (largest parasol). Katz donated more than 30 gallons of milk and ice cream for the event, which was attended by 300 youngsters.

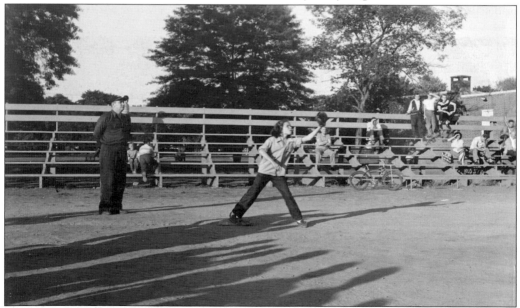

BOYS AND GIRLS OF SUMMER, 1951. Baseball clinics were offered as part of the recreation program. Here, Barbara MacKinney, daughter of oil deliveryman Bob MacKinney, practices catching as the June evening shadows grow longer. An editorial in the *Daily Home News* from the previous year praised the borough for sponsoring competitions in keeping with the values of small-town America despite being politically divided with a Republican mayor and Democratic council.

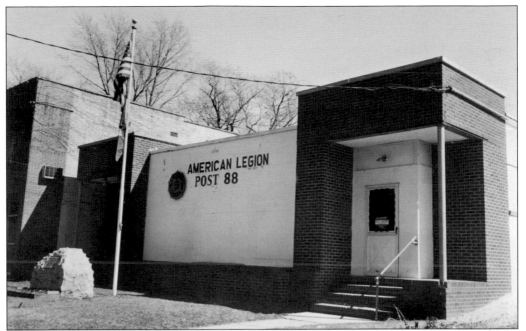

NEW HALL FOR AMERICAN LEGION POST 88. On June 27, 1950, the American Legion dedicated its new hall at 808 Raritan Avenue (above). Membership was surging, and the group outgrew its old headquarters in a 19th-century house on Benner Street. New Brunswick architects Woerner and Woerner designed the one-story brick building, which was built by Nora Construction Company for $21,000. In front of the building, they installed a granite boulder with a bronze plaque listing the names of those killed in action during World War II (below). Ruth Jansyn took these photographs in 2002.

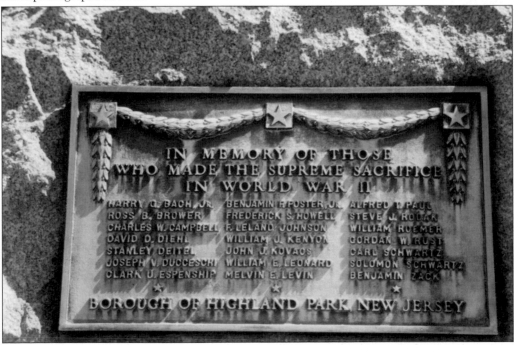

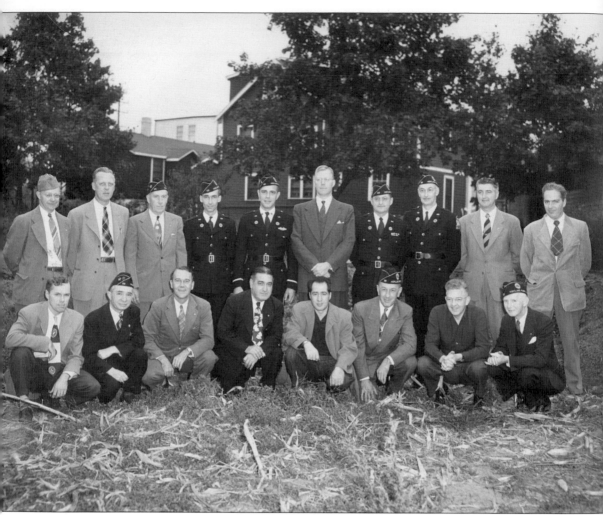

GROUND-BREAKING CEREMONY FOR NEW HEADQUARTERS. Unfortunately, not all of these Post 88 members who attended the ground-breaking ceremony for the new headquarters were identified. In 1950, membership numbered 150 veterans. In a 1944 brochure, the post historian suggested that over the Legion door should be written, "Leave your prejudices and petty jealousies behind." He hoped that vision and maturity would carry his beloved Legion on to still greater service to the community. After years of such service, which included sponsoring picnics, parades, and casino nights, by 2002, membership fell to fewer than 30, and the building was sold. A private gym is now located in the remodeled Legion hall.

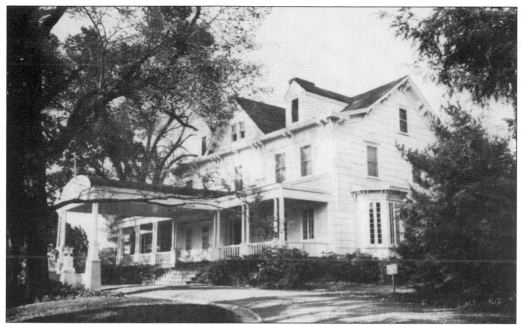

ROBERT WOOD JOHNSON JR. ESTATE CHANGES HANDS. From 1950 to 2004, the Sisters of the Cenacle operated a religious retreat on the former estate of Robert Wood Johnson Jr. Located at 411 River Road, the idyllic property once contained one of Highland Park's most historic houses and the oldest outbuilding. These two postcards, showing the main house's exterior (above) and parlor (below) are from a set printed just after the Sisters opened their retreat. Because the town lacks a historic preservation ordinance, the estate was recently sold to a private developer who turned the historic farmland into a tract of townhouses. Johnson's former summerhouse, built in the 1860s, was also demolished in 2011.

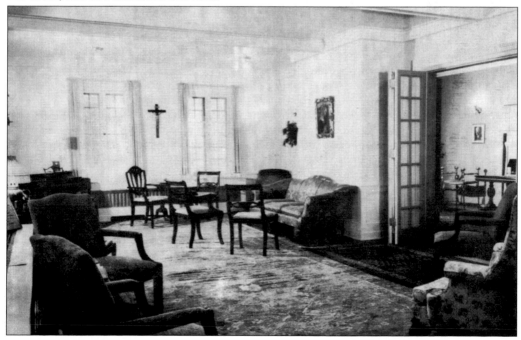

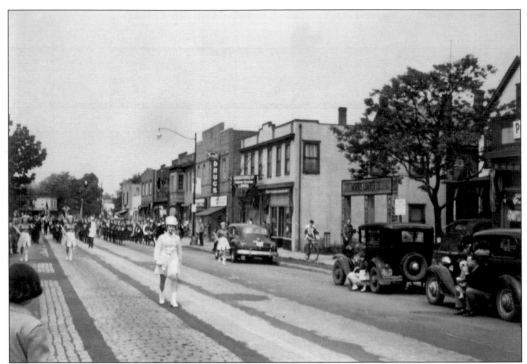

MEMORIAL DAY, 1950. Despite its slight blurriness, Helen H. Torrey's photograph shows an important section of Raritan Avenue between First and Second Avenues. The lineup of two-story brick commercial buildings constructed in the 1920s is the most cohesive block on the main street. This snapshot also shows a mix of older Model Ts, still on the road, near a 1940s sedan. Torrey donated her photograph to the historical commission, which was active in the 1970s.

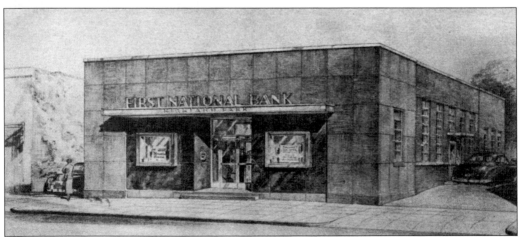

FIRST NATIONAL BANK OF HIGHLAND PARK. This illustration of the new bank building was included on the bank's annual holiday greeting card. The bank was first established at the Masonic Temple, and on June 17, 1950, it relocated to its modern one-story sandstone and granite building at 315 Raritan Avenue. The spacious interior had air-conditioning, and the standalone building had a drive-through teller for motorists. In the 1990s, the building was converted into a store; more recently, P.J.'s Coffee Shop operates out of this building.

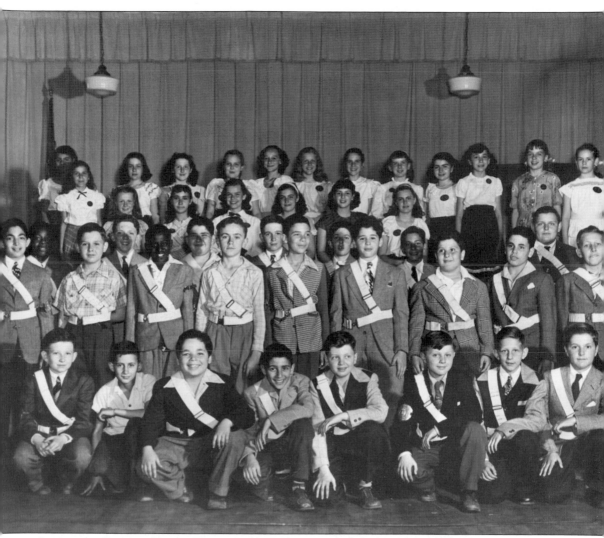

LAFAYETTE SCHOOL SAFETY PATROL, 1951. These unidentified Lafayette School students took their jobs assisting the safety officers in school very seriously, although the formal photograph with several children smiling widely shows they also had fun. Their duties included hall monitoring and assisting the crossing guards. In 1951, Lafayette School had an enrollment of 428 students and 14 teachers under Principal Helene Meagher; 603 parents were PTA members.

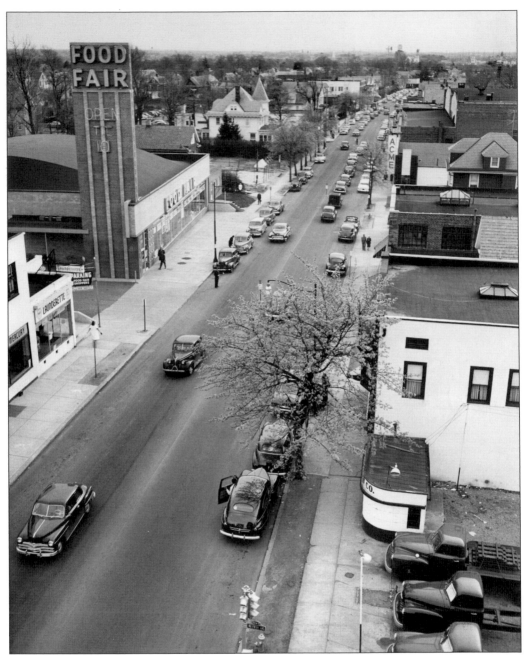

RARITAN AVENUE TRAFFIC STUDY. On April 18, 1952, several sections of Raritan Avenue were under scrutiny by photographer F.J. Higgins. Traffic patterns were noted to determine the need for traffic signals to replace police officers at several intersections. This photograph, taken at 5:26 p.m., looks west from the five-story Ausonia Apartment building at Fifth Avenue. Among others, it shows the original Food Fair building at the sidewalk line and Dr. Syndey Smith's house that was once on the corner of South Fourth Avenue.

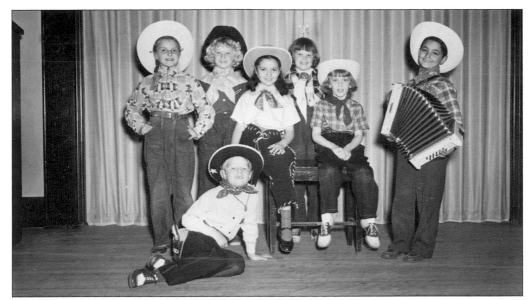

HI-LITES SHOW, 1952. The third annual Hi-Lites show sponsored by the recreation program took place on May 17, 1952. Over 35 children in the chorus dressed as cowboys and cowgirls to perform songs such as the opening number, "Hi Neighbor." Over 700 people crowded the high school auditorium to see the show. Cowgirl Arlene Kish had them join in along with the chorus for the grand finale of "Deep in the Heart of Texas."

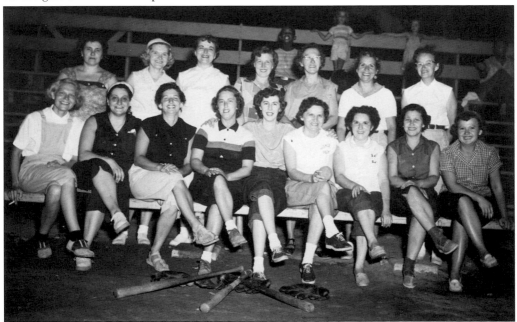

MOTHER'S BASEBALL TEAM. Pitting mothers against their Little League sons in a championship game on August 19, 1953, was a night to remember. The game ended in a 12-12 tie. Pictured from left to right are (first row) Pauline Lauer, Marie Policastro, Ethel Fertig, Alberta Policastro, Rita Goldstein, Esther Christian, Mary Schmitt, Betty Schwartz, and Mae Carkhoff; (second row) Jessie Chilakos, Anne Smith, Margaret Roster, Betty Borden, Marge Kubiak, Mary Vanacore, and Catherine Inglebrand. Kubiak's son Ted went on to have a career in major-league baseball.

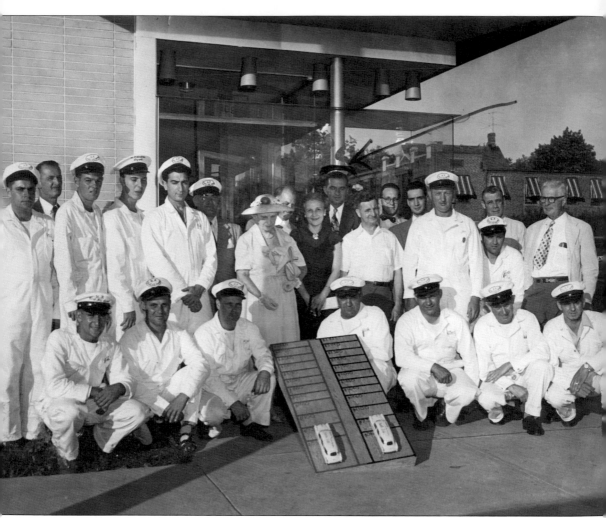

FIRST AID SQUAD FUND DRIVE, 1952. In 1950, its first full year of operation, the First Aid Squad responded to 281 calls for assistance. At first housed at MacKinney's Oil Company building, the squad began to raise money for a new headquarters in 1952. Here, members gather around benefactors Helen McCallum and Elizabeth Brown in a publicity photograph. The two toy ambulances represented the competition between the two sides of town, north and south. As money was raised, the ambulances moved up the board, which was displayed in Dakelman's Pharmacy at Raritan and Third Avenues. The south side won the contest as the fund drive exceeded its quota. The new headquarters was constructed on South Eleventh Avenue just off Woodbridge Avenue on land leased from the borough for free.

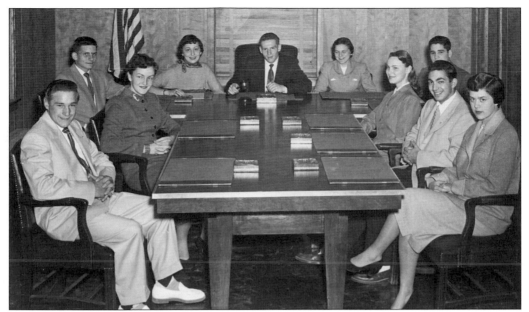

YOUTH MAYOR AND COUNCIL FOR A DAY. Members of the Highland Park Youth Council, all high school seniors, who took over administrative affairs of the borough for a few hours on May 3, 1954, are, from left to right: August Losso, Ellen Billheimer, borough engineer Richard Clewell, borough clerk Sue Hanoka, mayor Ted Buckner, president of the council Joan Sapiro, borough attorney Samuel Ratner, Nancy Dorian, Arthur Gelfand, and Diane Cottle.

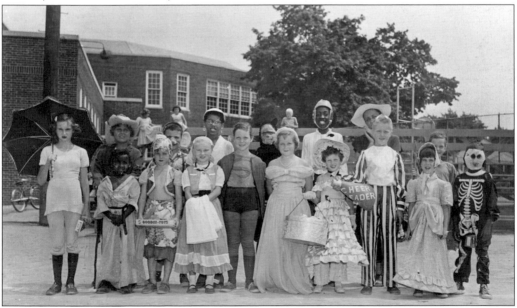

KATZ PARTY COSTUME WINNERS, 1954. Longtime residents remember Herman Katz Days sponsored by the recreation program. On July 29, 1954, Katz's Kostume Party awarded prizes for Kutest, Kuaintest, and Korniest costumes. The winners were, from left to right, (first row) Ramona Calvo, Judy Haskins, Herman Calvo, Allen Loore, Joan Alessi, Ellen McDonald, Cathy and Thomas Hammell, Mary Calsurdo, and Richard Bell; (second row) Marcella Calvo, George Ryons, Clarence Hare, Arthur Hammell, James Bell, Barry Marzella, and Mary Ann Grey.

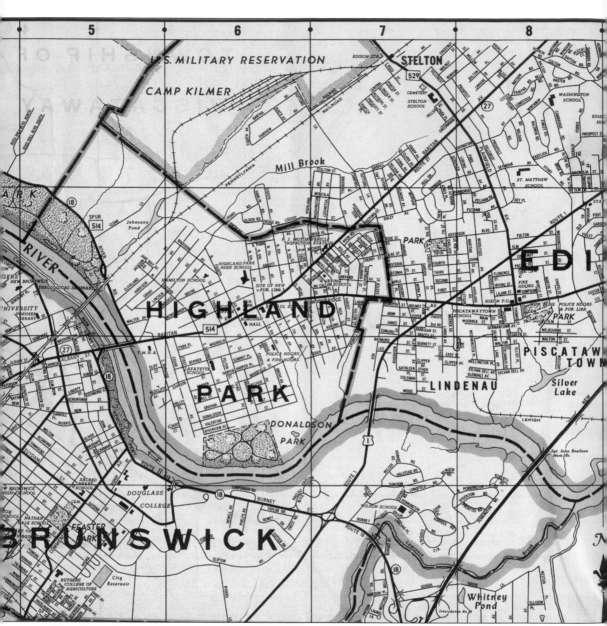

HIGHLAND PARK ON THE MAP. This map from around 1955 shows Donaldson Park and the new Young Men's Hebrew Association facility in the old Meyer-Rice mansion at South Adelaide and Raritan Avenues. Other landmarks include the new firehouse on South Fifth Avenue and the borough hall in its former location on South Fourth Avenue. The public library is shown in its old location on North Fourth Avenue. By this time, the short streets off South Adelaide Avenue such as Elbert Court had been established. Outside of Highland Park, the large property of Camp Kilmer is shown to the north of town.

WHO DOESN'T LOVE A PARADE?
On May 14, 1955, the borough
celebrated its 50th anniversary
with a spectacular parade, an
anniversary ceremony, and
dedication of the new fire-police
building. Youngsters Marilyn and
Billy Weingardt of Edison watched
the parade (right), which included
bands, borough organizations,
guests, and floats, one of which
had an automobile from 1901.
Visiting dignitaries riding in a
lineup of cars included, in the
lead car, Brig. Gen. John Sitz,
who was commanding general
at Camp Kilmer, and Lt. Col.
R.E. Phillips, acting commander
at Raritan Arsenal (below).

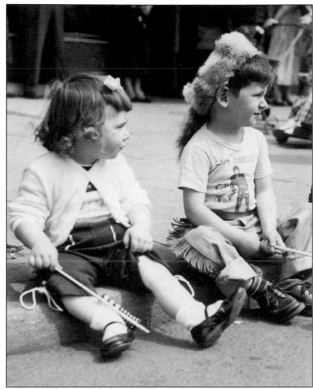

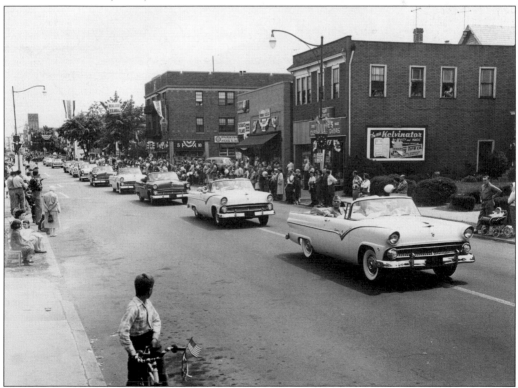

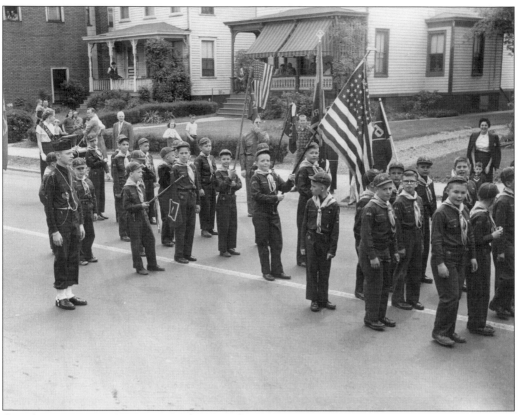

Cub Scouts Help Celebrate. This is Cub Scout Pack 64 of the Trinity Methodist Church participating in the 1955 parade. Notations on the back of the photograph listed a few names, including Pack Leader A. Franklin Deuble, Scoutmaster Paul Hunter, and Scouts Thomas Welshman, Peter Dorsen, Sam Silverman, Robert Alum, and Jeffry Beitler. Richard Isaacs is the American flag bearer.

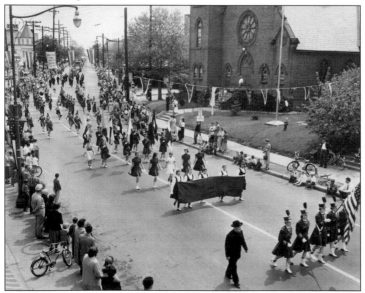

New Brunswick's St. Peter's Participates. St. Peter's High School band was judged the prizewinner for bands and drum corps. Here, it is marching past St. Paul's Church, which was originally built in 1912 as a suburban chapel of New Brunswick's St. Peter's Church. Monsignor James Harding (dressed in all black) marched at the front of the contingent for the entire length of the parade, for which he was much praised, as other notables rode in cars.

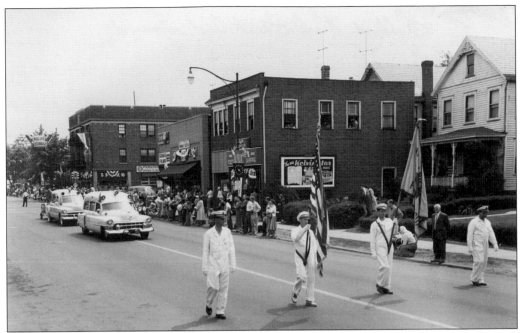

First Aid Squad Marches Along. Here are members of the Highland Park First Aid Squad, the newest organization in the town's first half century, preceding their two ambulances as the parade passed the cluster of buildings on Raritan Avenue at South Third Avenue. President of the squad James J. Carolan spoke to a *Daily Home News* reporter and stated, "Our only goal is to be put out of business." It didn't come to pass, as their services are still needed and appreciated to this day.

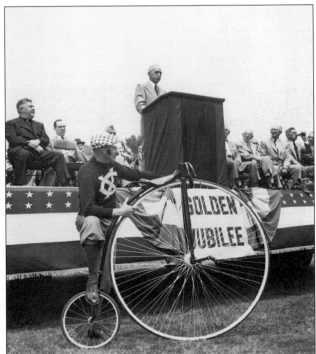

Keynote Speaker, Former Mayor of Highland Park. Gen. Robert Wood Johnson Jr. (1893–1968), pictured here at the podium, was the principal speaker of the celebration. He paid tribute to the borough and its officials as he urged residents to show their appreciation for the beneficial type of householder government established here. He was quoted saying, "The front line for freedom is our town. Local government is essential in the pursuit of freedom and happiness."

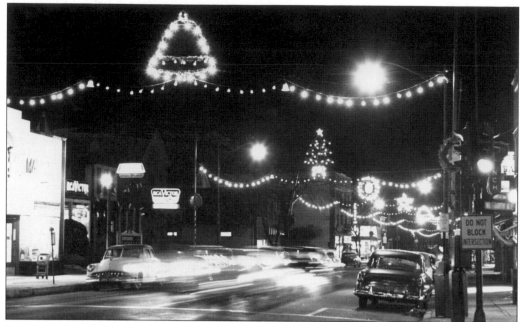

NIGHTTIME DECORATIONS. Taken in 1958 looking southwest from the corner of Raritan and North Fourth Avenues, this photograph by *Daily Home News* photographer Will Gainfort shows the Christmas decorations along Raritan Avenue. Walter W. Wright, president of the chamber of commerce, lit the lights on December 2 that year, an early start for the festive season of shopping. Business owners formed the local chamber of commerce in 1947.

HIGH SCHOOL DRAMA. Highland Park was fortunate when, in 1958, Robert W. Stevens (1927–1986) was hired to be a high school teacher. Born and raised in Virginia, Stevens attended William and Mary College. He made his name here as a speech teacher and theater arts director for 28 years. This photograph from 1962 shows him at far left with members of the *Alice In Wonderland* cast, (from left to right) Roxana Rubin, Jack Whitham, and Randi Landrum.

HIGHLAND PARK HIGH SCHOOL, 1959.
The high school building is a local
landmark. Designed by Alexander
Merchant, it was constructed in
1926 as a junior high school. The
grand, formal entranceway with
its two-story portico has always
elicited a sense of humble pride as
one approaches and opens the heavy
door to enter. The white-painted
dome gave rise to the name of the
high school yearbook, *Albadome*.

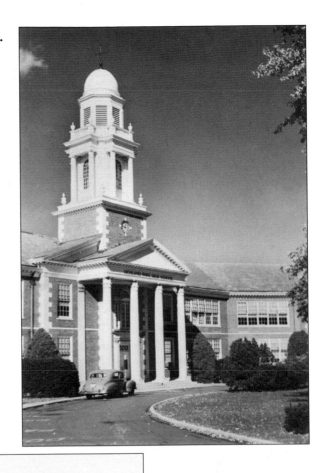

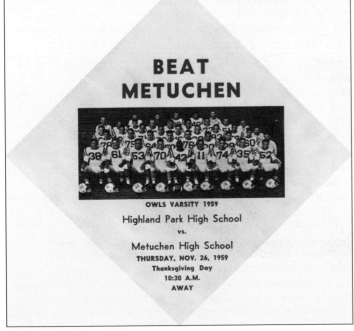

**SCHOOL PRIDE AND
TRADITION.** Another
source of school pride
is the football rivalry
between Highland Park
and Metuchen, which
began in 1939. Games are
played on Thanksgiving
Day each November; as of
2011, Highland Park has
dominated the series with
59 wins, 17 losses, and 1 tie.

"AN EVENT OF A LIFETIME." So proclaims an invitation from the Committee for Israel Bonds for a March 8, 1959, event at the Highland Park Conservative Temple Center. Golda Meir, minister for foreign affairs of the state of Israel, spoke at this Dinner of Welcome. More than $250,000 of bonds were sold as a result of her inspiring address, which is quoted here. This article appeared in the March 13, 1959, edition of the *Jewish Journal*.

CONFIRMATION CLASS REVISITED. When it was first included in the 1999 Arcadia Publishing *Highland Park* book, all the young ladies in this Will Gainfort photograph of a 1951 Conservative Temple confirmation class were unidentified. Now six of the seven have been identified. Included are Harriet Berkowitz, Roberta Howard, Arlene Lieberman, Grace Amar, Rhonda Zankel, and Barbara Feinberg.

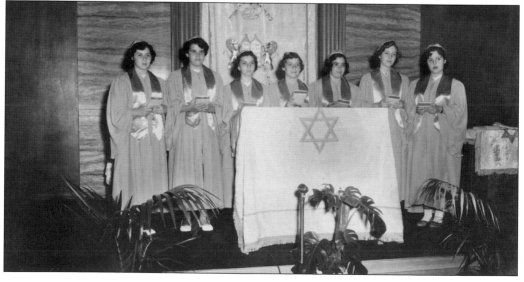

Receipts Saved for 50 Years. Peg Maranca donated these receipts she saved for 50 years to Lois Lebbing, who in turn donated them to the historical society in 2008. Beginning in 1947, Lebbing's father, George Collier, ran the Esso gas station at 126 Raritan Avenue. From the receipt pictured, we see that in 1959, a quart of oil cost 50¢.

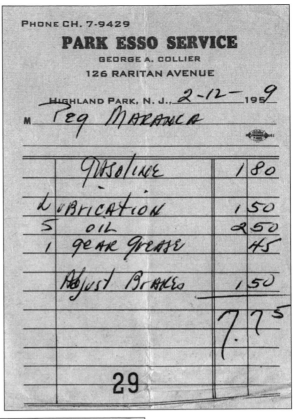

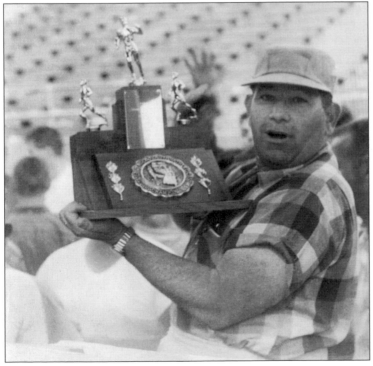

Dakelman Holds State Track Championship Trophy. In 1959, Jay Dakelman (1922–1991) became head football coach at Highland Park High School. However, he was not new to Highland Park High School athletics. Beginning in 1946, he was a physical education teacher, freshman basketball coach, and head track coach. Here he holds up the state track championship trophy his team won in 1960.

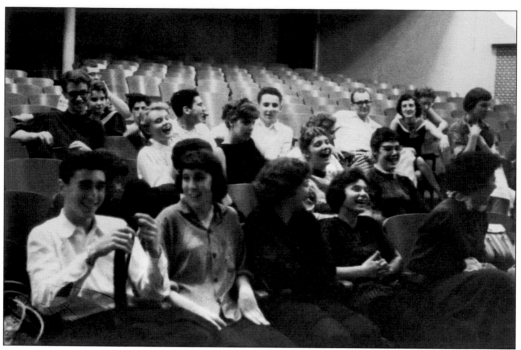

I Remember Mama, 1959. The historical society archive includes over 400 photographs, programs, and articles from the high school drama department. This *I Remember Mama* program and photograph of an audience in the auditorium, perhaps the cast members and crew, date to May 1959. In a lasting tribute to Robert Stevens's long tenure as director of the drama department, the high school auditorium was named for him after he died in 1986.

THE PLAY, IN TWO ACTS, TAKES PLACE
IN SAN FRANCISCO

THE TIME IS AROUND 1910

THERE WILL BE A FIFTEEN MINUTE INTERMISSION
BETWEEN THE ACTS

Tonight's performance is sponsored by the Highland Park High School Student Council. All proceeds from the production will be contributed to the American Field Service Foreign Exchange Fund.

Under the Exchange program for 1958-59 we have been host to Aslaug Madland, whose home is Norway. We are especially happy to have Aslaug as a cast member of our production.

In June, James Weiss, a student of Highland Park High School, will go to Germany to spend the summer as the guest of a family in that country.

Your patronage of tonight's performance will help to make possible the continuation of the exchange in 1959-1960, enabling another foreign teenager to live and study in our town, and one more of our students to go abroad in the summer.

The Cast

KATRIN	Dorothy Gowen**
MAMA	Joyce Sano**
PAPA	Bruce Baltin
DAGMAR	Alice Aaron
CHRISTINE	Aslaug Madland
MR. HYDE	Aaron Sapiro*
NELS	Steve Porges
AUNT TRINA	Kathy Hofland
AUNT SIGRID	Gerri Jacob
AUNT JENNY	Janet Ehrlich**
UNCLE CHRIS	Louis Seagull*
MR. THORKELSON	Joe Eletz*
DR. JOHNSON	Dan Vasey
ARNE	John Smith
NURSE	Sandi Veres
SODA CLERK	Jerry Levitt
ANOTHER NURSE	Carol Heines**
MADELINE	Sue Katz
DOROTHY SCHILLER	Anita Mironov**
FLORENCE DANA MOOREHEAD	Elaine Levine**
BELL BOY	Mike Smith

* Candidate for Membership Troupe 805 — National Thespian Society
** Member of National Thespian Society Troupe 805

76

Four

THE SIXTIES

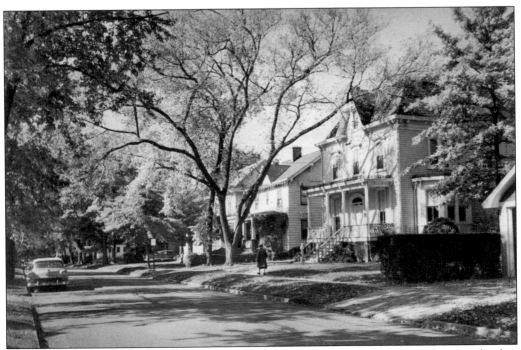

STREETSCAPES. In 1961, an unidentified person took a series of black and white photographs that documented many streets and buildings in Highland Park. The photographs became part of the historical society's collection in the 1990s, and many are included in this chapter. Here is the 100 block of Benner Street between South First and Second Avenues, which was first established in the 1860s by brothers Hiram and William Benner.

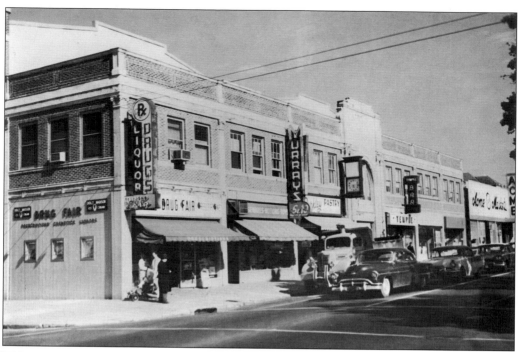

THE MASONIC HALL AND WRESTLING MATCHES. The Masonic Temple (above) had a large auditorium toward the back where many entertainment events from 1923 to 1965 were held. The first and second stories at the front, seen here in 1961, held stores and offices. Until 1951, this was the address of borough hall. The wrestling program (left) is a memento of the semi-professional wrestling alliance that held events every Friday night. Long before professional wrestling became an international phenomenon in the 1980s, heavily televised with the advent of the World Wrestling Federation, independent events were staged at small local venues, such as the Masonic Temple, throughout the country.

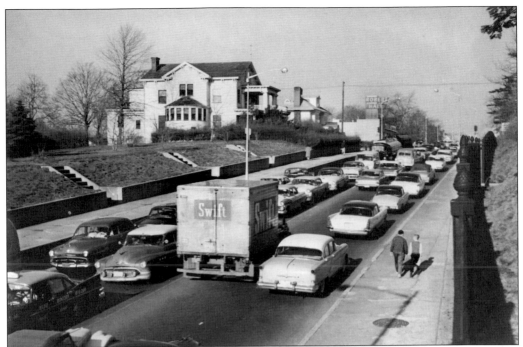

DENSER HOUSING PATTERNS. Between the early and late 1960s, the town underwent changes in the pattern of new housing. These two photographs show the change to the first block of Raritan Avenue just off the Albany Street Bridge. The top photograph of five o'clock traffic is dated 1961 and shows the north-side mansion on the left that once stood on the sloped lot. By 1967 (below), the mansion had been demolished and Parktowne House, a modern six-story, two-building, 84-unit apartment complex, filled the entire lot.

FIRE FIGHTING TRAGEDY. On May 26, 1958, firefighters William C. Graff and Frank R. Molimock died fighting a fire at Ten Broeck Motors, Inc., at 211 Woodbridge Avenue (above). They were two of the 100 firemen who responded, and they had ascended to the roof to fight the flames from above. They perished when the roof collapsed. No Highland Park firefighter has died in the line of duty since the 1958 fire. The Highland Park Fire Department always remembers these two brave souls as well as John Quinn, who was the first (in 1948) to die in the line of duty. The fire department's headquarters, which opened in 1955 on South Fifth Avenue (below), was photographed in 1961.

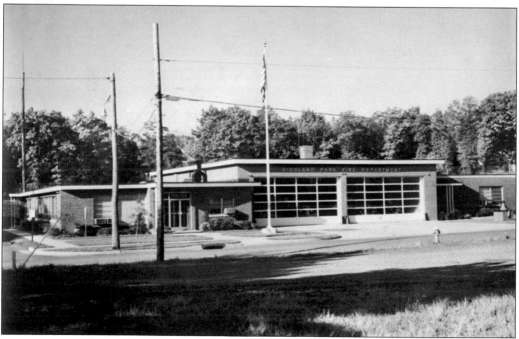

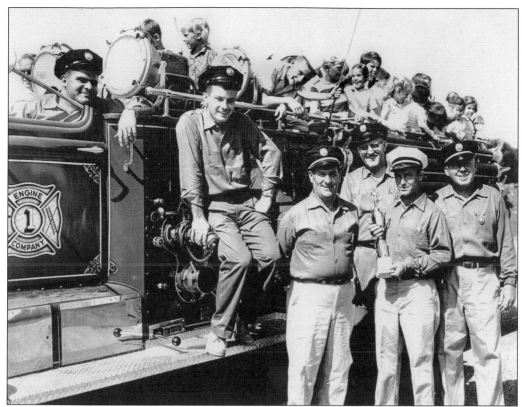

FIREHOUSE OPEN HOUSES. Firefighters are skilled personnel. They receive many hours of training in order to qualify. They are often also local heroes. The department conducts fire prevention programs in the schools, hosts an annual open house, and conducts special tours for smaller groups. Here are two photographs taken in the 1960s that perhaps show the next generation of firefighters when they had their first opportunities to be on a fire truck.

SALLY'S STEAKHOUSE. This landmark is located on the corner of Raritan and North Third Avenues. Sally's restaurant was a mainstay eatery in town from the 1940s until the 1970s. Initially opened as a tavern run by Sally and David Tischler, in 1952, Sally's daughter Dorothy and her husband Jerry Miller bought the restaurant. They expanded the business by incorporating the neighboring house and established Sally's as one of the finest steakhouses and meeting halls in the area. The postcard (below) is one of a set that was produced in the 1960s; nowadays, copies are often seen for sale at postcard shows and on internet auction sites.

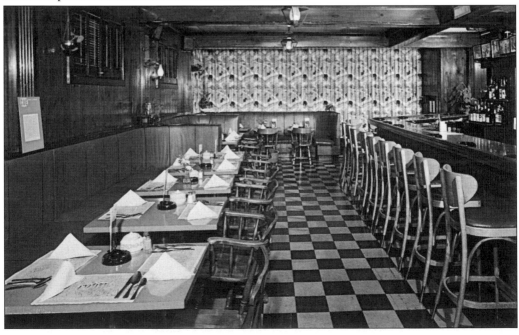

JEWISH COMMUNITY CENTER. The Meyer-Rice house on South Adelaide Avenue was purchased in 1955 and converted into the Jewish Community Center (JCC), which opened in July 1956. Membership grew so much that in 1958, a second building campaign began. Ernest Levine drew up plans for a large new addition that included a pool, locker rooms, a gymnasium, and a community room (above). The JCC continued to operate out of the mansion during construction. From 1961 to 2007, the JCC and later the Young Men's and Young Women's Hebrew Association ran the facility, hosting art and swimming lessons, operating a day care, and offering a kosher lunch for the elderly. The photograph of the center's sign (below) was taken in 1968. Now, nothing remains of this former community center in Highland Park, as its new owners demolished the building in September 2008.

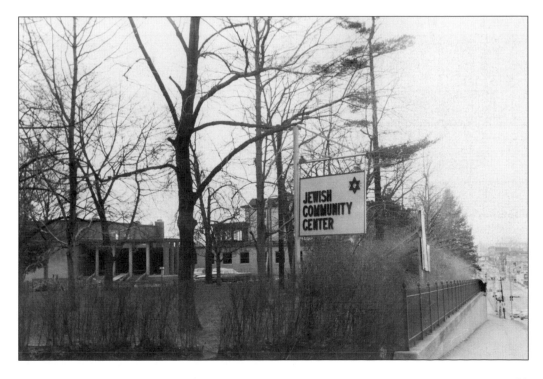

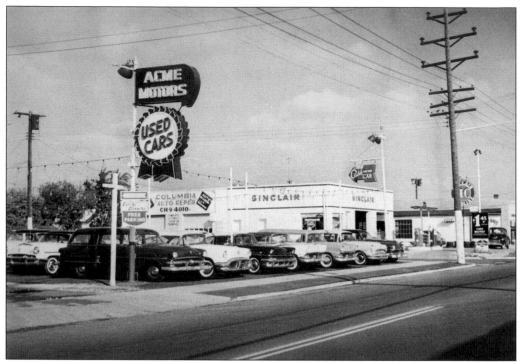

USED CAR DEALERSHIP. In 1961, many new car dealers had left for larger properties outside the borough's boundaries. Used car dealers set up shop in their place. Here, Acme Motors was located at Woodbridge Avenue at Columbia Street. Many automobile-related services can still be found along Woodbridge Avenue's stretch of commercially zoned properties.

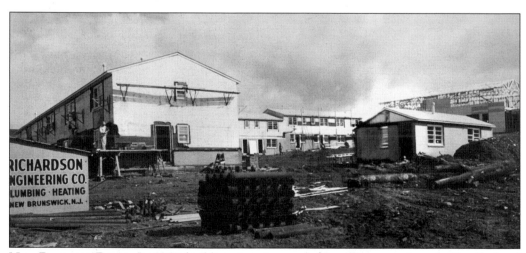

NEW BUILDING BOOM. In 1961, building permits worth $2 million were issued. The Orchard Gardens project, seen here under construction, transformed a hillside covered by an apple and peach orchard into multiple-family housing units. Located on the south side off Woodbridge Avenue, this complex dramatically increased the town's housing density.

HIGH JINKS AT THE HIGH SCHOOL. The Highland Park High School newspaper, the *Highland Fling*, published this 1963 April Fool's Day edition with a cartoon by L. Goldstein that spoofed the track team (above). That year, senior and state champion hurdler Ted Pisciotta led the team to much success. His fellow classmates voted him Best Athlete and Best All-Around. The back-to-normal article (below) featured on the front page of the June issue of the same year featured all the seniors voted "best" or "most likely to."

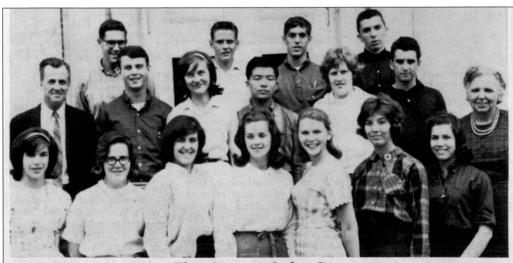

The Cream of the Crop

This year's Senior Top winners are, l. to r., first row: Nan Motolinsky, Best All-Around; Sharon Higgins, Did Most for the School; Sue Rabinowitz, Best Personality; Cathi Artandi, Most School Spirit, Best Looking; Randi Landrum, Most Talented; Betty Puskas, Best Athlete; Carol Greif, Most Popular. Second Row: Mr. John Sprout, Favorite Teacher; Bob Holland, Best Looking; Gerrylynn Kuszen, Most Likely to Succeed, Class Genius; Jim Matsumoto, Most Talented; Janet Steinhauer, Most School Spirit; Joe Schiavone, Best Personality; Mrs. Bertha Ellwood, Favorite Teacher. Third Row: Hank Jacob, Most Popular; Did Most for the School, Most School Spirit; Ned Van Heuvel, Class Genius, Most Likely to Succeed; Ted Pisciotta, Best Athlete, Best All-Around; and Butch Rulewich, Class Clown, Teachers' Torment. Absent from the picture is Mary Ann Zafarana, Class Clown and Teachers' Torment.

Television Comes To Hamilton School

About four weeks ago, Mrs. Hess and I were discussing the rather startling results that occurred when her first grade did calisthenics to currently popular show record. We both agreed that parents would enjoy seeing such coordination and I recalled that two years ago Allen Funt taped a similiar exercise in Northvale for the Candid Camera program.

"Candid Camera" said they were very interested and would contact me about a date. Nothing happened...(I am told sometimes T.V. works like this!) Finally on Thursday March 5th - our school was called and "Candid Camera" arrived. But there was a change. Mr. Funt is the host of both Candid Camera and a program called, "Tell It to the Camera," (Wednesday, C.B.S. Channel 2, 8:30). The change was - they now wanted some pupils simply to answer three questions for the camera and that the camera would not be hidden.

The director asked three questions - "what would you change your name to if you could change your name?"; "What subject would you like taught in school?" and "What would you like - all boys, all girls or mixed boys and girls in your class?"

The show's director wanted to speak with children who would not tense-up when they saw the camera. He repeatedly expressed what I felt was genuine praise for the poise the pupils had. I'm sure you're familiar with the show and realize they generally select an answer that has a "twist" to it.

As of this moment - the taping will probably be aired tomorrow night - Wednesday, March 11th. C.B.S. at 8:30 P.M. You realize further that a T.V. show of this type has many pressures and they might postpone this particular tape until next show - March 18th. However, as of this moment - it is scheduled for tomorrow night.

One reason I dealt with details here is that where children are excited by bright lights and cameras and sound equipment - I don't know what you might hear at the supper table.

Cordially,

Leo V. Fallou

P. S. If you are wondering whether your son/daughter will be on - Mr. Funt will call and get your permission.

NOT THE TYPICAL LETTER HOME FROM SCHOOL. In March 1964, Allen Funt of television's *Candid Camera* visited Hamilton School and interviewed several students for his other program, *Tell it to the Camera*. This is the letter sent home on March 10 from the principal, Leo Fallou. Surely, all the televisions in town were tuned to this program on the evening in March 1964 when it aired.

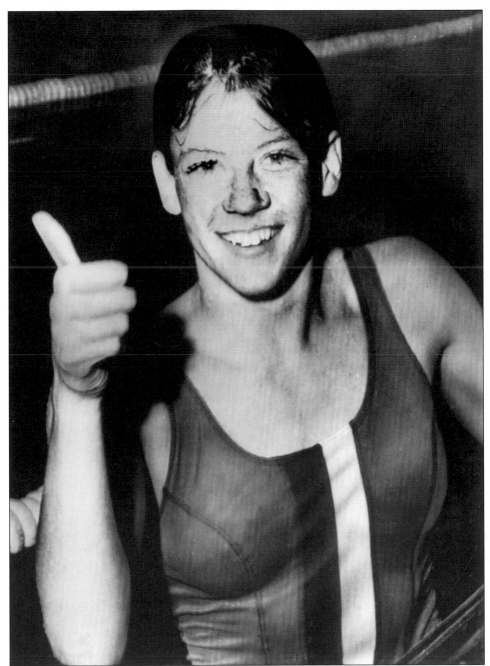

CHAMPION SWIMMER SUE PITT. As a 16-year old at the 1964 Summer Olympics in Tokyo, Highland Park resident Sue Pitt swam in the preliminary heats of the women's 4×100 meters medley relay. Her speedy teammates prevailed, taking home the gold medal. She is pictured here a year later in Cardiff, Wales, after she set a world record time in the 220-yard butterfly. She also participated in the 1968 Olympics in Mexico City. Building her career around swimming, she founded the Scarlet Aquatic Club at Rutgers University and was its head coach for many years. Since 2000, she has been the Director of Programs and Services at USA Swimming, the national governing body for the sport of swimming in the United States.

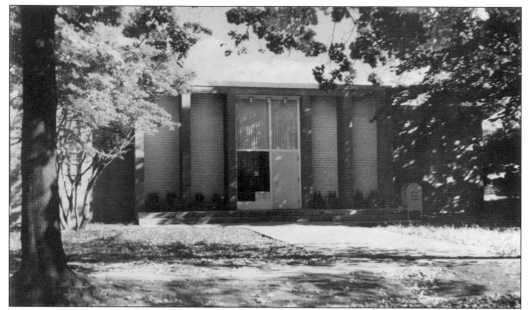

HIGHLAND PARK PUBLIC LIBRARY. Highland Park finally constructed a brand new building for its library in 1959. Designed in the Modernist style by Ernest Levine, it was located on the former Lucas property between North Fifth and Sixth Avenues near the high school. The main facade and entrance was originally on North Sixth Avenue. In 1959, an unidentified photographer took this picture of the more attractive North Fifth Avenue facade with its back door.

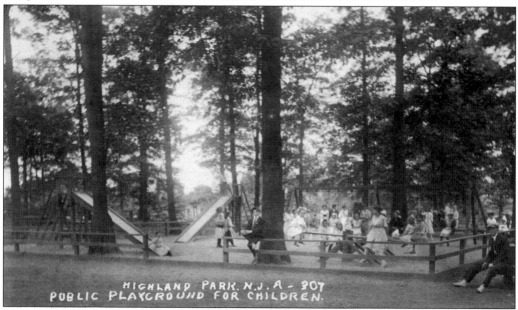

HISTORY'S MYSTERIES, KARSEY STREET PLAYGROUND. Could this undated, real-photo postcard from around 1910 be showing the same parkland that would be transformed into the Karsey Street playground in 1952? Conveniently accessed by the Woodbridge Avenue trolley line, in the late 19th century, the Aurora Singing Society used its property of old-growth trees off Woodbridge Avenue between Karsey and Hilton Streets as a play area and picnic ground. In the 1920s, Forest Park amusement center was located on this property for a few years.

KARSEY STREET PLAYGROUND, 1961. Here are two views of the Karsey Street playground taken years after it was first established in 1952. Then, Councilman Frank Grover said the area could be converted into a small park. Benches were provided, and attempts to obtain playground equipment were successful. These two photographs show the park from two different vantage points in the 1960s. The top photograph is the view toward Hilton Street, and the bottom view of the basketball court is looking toward Karsey Street.

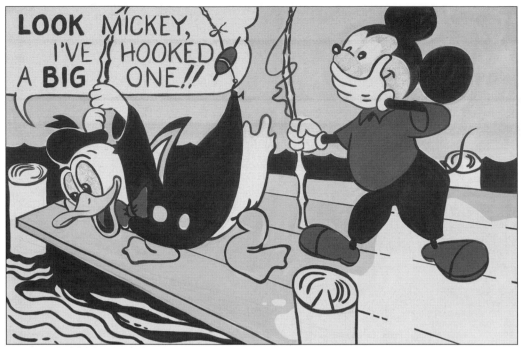

ROY LICHTENSTEIN LIVED HERE. From 1960 to 1963, Roy Lichtenstein (1923–1997), an instructor of design at Douglass College, lived in Highland Park. *Look Mickey*, now at the National Gallery of Art, was painted in 1961 and is considered Lichtenstein's first Pop Art creation. Local legend has it that he painted it in the bedroom studio of 66 South Adelaide Avenue where he was residing. (Courtesy National Gallery of Art, Washington.)

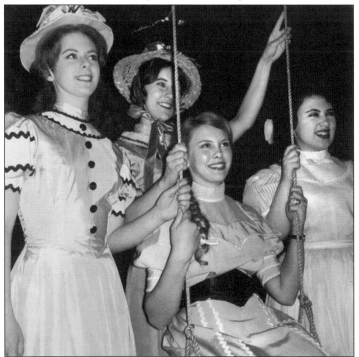

YOU'VE GOT TO HAND IT TO LITTLE MARY SUNSHINE. In March 1963, there was so much talent in the high school drama department that a performance of *Little Mary Sunshine* had different actors portraying the character of Little Mary on different nights. Cathi Artandi played the title role on Friday and Monday, while Wendy Weiner (far right) was Little Mary on Thursday and Saturday nights.

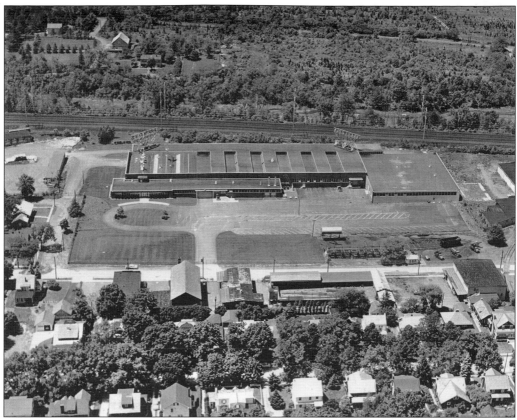

ROSS ENGINEERING. The last big industrial plant in town was first built just after World War II on the former wallpaper factory site at 233 Cleveland Avenue. Ross Engineering was a division of Midland-Ross Corporation that designed and fabricated custom sheet metal for industries. In 1965, around the time Joseph Koye took this aerial photograph, George Schuning was general manager and Robert Dougherty was operations manager. This company continued operations into the 1990s. (Courtesy of Rich Odato.)

CRONK BOX CORPORATION

PACKING CASES and
WOOD SPECIALTIES

Telephone
CHarter 9-0717

401 Cleveland Ave.

New Brunswick, N. J.

CRONK BOX CORPORATION. In 1918, Harold Richard Segoine (1887–1971) became president of a wood box and packing crate manufacturer located at 401 Cleveland Avenue. During World War II, this company made wooden boxes for transport of war supplies to the troops in Europe. Segoine was still listed in the 1965 New Brunswick directory as president, with his son H.R. Segoine Jr. as assistant secretary.

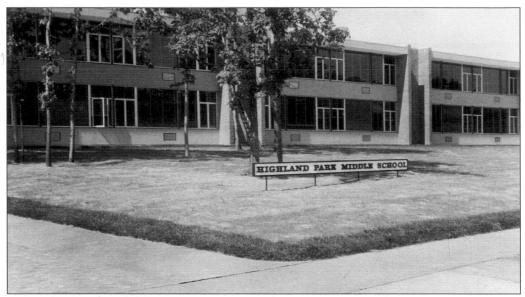

BABY BOOM SCHOOL EXPANSIONS. In 1965, the Highland Park Board of Education introduced a school expansion plan that included a new 20-room middle school, more classrooms at Irving School, and a new wing for the high school. In 1967, architects Eckert and Gatarz designed the middle school shown above, which would be renamed Bartle School. The two-story wing at the high school would include a library, an audio-visual room, and five large classrooms. This addition was still under construction in 1967 (below). During 1967 and 1968, the Highland Park Women's Club established a program of beautification that included planting flower gardens at all the schools. The club provided funds, hired a landscape architect, and coordinated the actual work of planting bulbs, ground covers, and flowering cherry and quince trees.

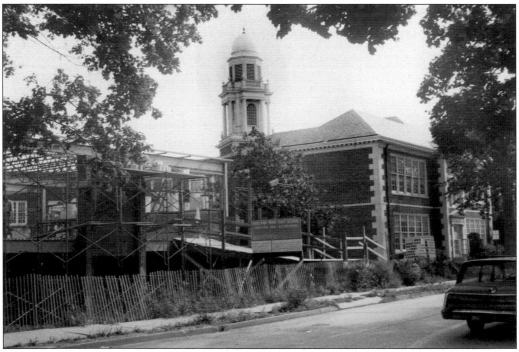

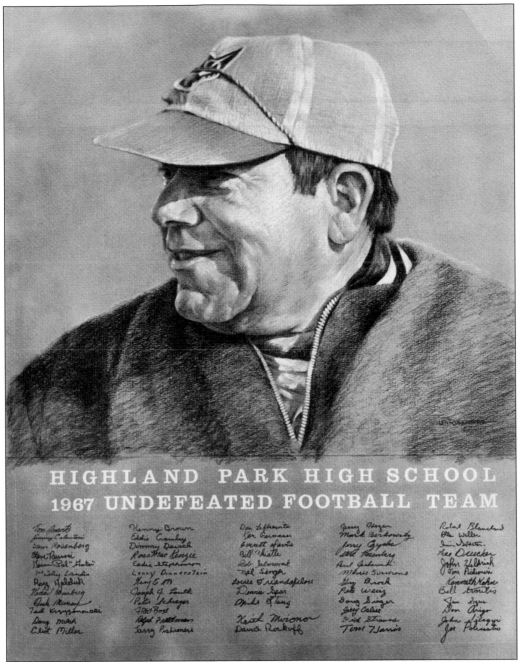

UNDEFEATED YEAR IN FOOTBALL, 1967. Jay Dakelman's first year as head football coach in 1959 saw his team go undefeated with a 9-0 record. It happened again in 1967. To commemorate the outstanding achievement, Len Rosenberg drew this portrait of the coach, and members of the team signed their names. Assistant coach Joe Policastro also signed the poster. Policastro would take over as head football coach in 1978 after Dakelman retired from the position.

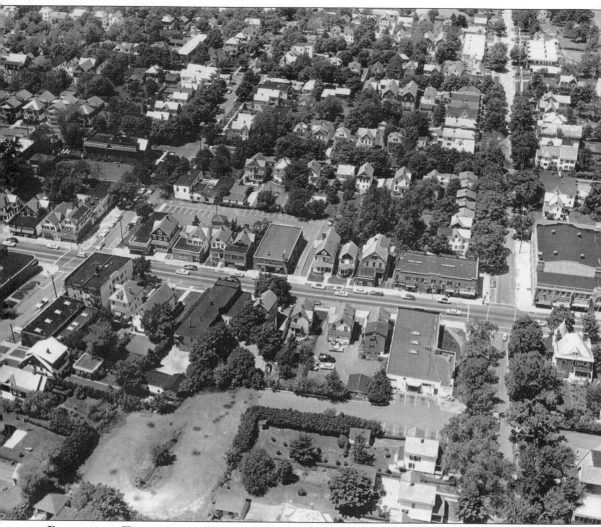

FLYING OVER TOWN WITH A CAMERA. Joseph Koye was responsible for photographing most of Highland Park from the 1940s through the 1970s. Thanks to his family, including son Frank Koye and nephew Rich Adato, who saved many of them, Highland Park has a comprehensive record of itself. This aerial photograph looking north shows Raritan Avenue between Third and Fourth Avenues and the residential sections flanking the main street. It dates to before March 1965 because the Masonic Temple, seen on the far right edge, still has its upper floors. (Courtesy of Rich Odato.)

JOSEPH KOYE, PHOTOGRAPHER. The practice wedding photograph to the right is a self-portrait that Joseph Koye (1930–1984) made. His son, Frank Koye, donated it and stated, "My father started his photography business during WWII printing up portraits of soldiers and later, his friends' weddings. He was first to make outdoor wedding portraits in parks, particularly New Brunswick's Buccleuch Park. His studio was first on Raritan Avenue, then in the house at South Fifth Avenue." Joseph Koye was hired into the Highland Park Police Department in 1956. He was often asked to perform borough-related photography. Below is an unidentified photograph of a snowy scene on one of the south-side streets. Perhaps it was used in a discussion about the borough's snow removal operations, or was it an accident scene? It'll never be known, as most of Koye's work was not archived.

HIGHLAND PARK HIG

PANORAMIC GROUP PORTRAIT, CLASS OF 1968. As the politically turbulent decade of the 1960s drew to a close, one tradition continued. That was the annual Highland Park High School senior trip to Washington, DC. Here, the members of the class of 1968 and their chaperones pose for a panoramic photograph with the Capitol building as the backdrop. These students were the first to fall under new guidelines about the observances of specific religious holidays. An article in the *Home News* on January 11, 1967, detailed the new policy, which stated, "A public school may not observe specific religious holidays as though it were a church or group of churches." The schools were allowed, as educational institutions, to discuss the holidays, and decorations could continue according to secular customs using non-religious symbols. In 1968 and onward, race relations and

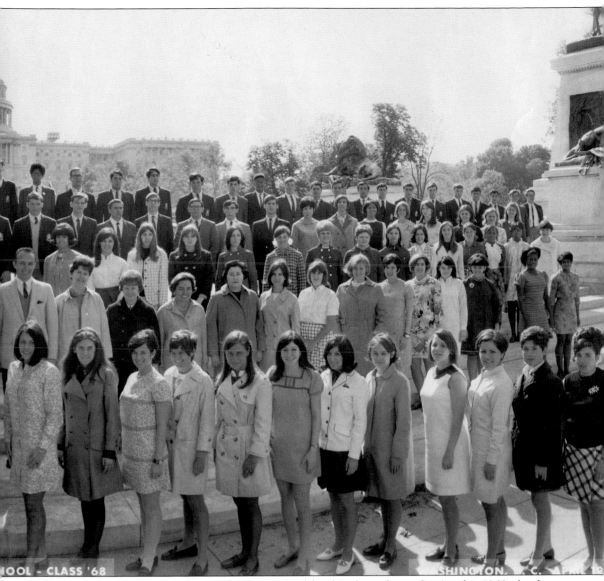

the Vietnam War were on the minds of many Highland Park residents. On April 4, 1968, the day that Martin Luther King Jr. was assassinated, Fred Klein remembered that he rode his bicycle to the Albany Street Bridge and witnessed the Highland Park police barricading the bridge, allowing no one to come over from New Brunswick that night. On June 5, 1968, Highland Park lost one of its young men, Marine Corps member Joseph Klein, who died in Vietnam. Three years later, on July 8, 1971, the town would lose another young man, Wayne Pisciotta, to the same war. So as to never forget, in 1994, a Vietnam memorial plaque bearing these two names was installed at the high school.

MAYOR HERBERT M. TANZMAN. An article in the *Home News* on November 15, 1964, stated that Herbert Tanzman was stepping away from local politics after serving as a borough councilman for nine years. He came out of retirement a year later to serve two terms as mayor, from 1966 to 1969. Tanzman, seen here fourth from the left in an undated photograph, was a Democrat and an advocate for veterans' affairs. He was a member of the National Executive Committee of the Jewish War Veterans. He was quoted saying that, while working on behalf of Jewish veterans, he hoped that the day would soon come when a veteran's religion wouldn't be considered in any way, shape, or form.

Five

THE SEVENTIES

A DAY IN THE LIFE OF A TOWN. In 1979, several League of Women Voters photographers took pictures of scenes in town for their publication *This Is Highland Park*. It was the last in a series that started in the 1950s. This photograph shows the high school marching band on parade.

PHOTOGRAPHY PROJECT C. 1972. The next 10 photographs were part of a study of Highland Park businesses located on both Raritan and Woodbridge Avenues taken by Joseph Koye. The borough clerk donated a box of his negatives to the historical society in 1998. Ruth Jansyn printed up several dozen, some of which are included here. The top photograph shows the former Moderne-style gas station at 60 Raritan Avenue. That building was first built as George Terra Nova's filling station in 1940. Having served as a gas station for 60 years, it was demolished in 2000. The small Dunkin Donuts building (below) with two very large neon signs was built between 1963 and 1969. This is one of only a few national chain businesses that have ever been in town.

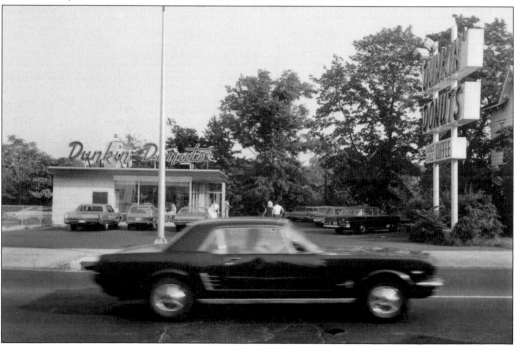

125–141 RARITAN AVENUE. The five buildings seen on this page were built at various times from 1895 to 1928. The top photograph shows 125 (left) and 127 Raritan Avenue (right). Since the early 1920s, tailors, dry cleaners, and a bike repair shop have occupied 125 Raritan Avenue. Its neighbor started out as a new car dealer in the 1920s, then became an auto repair shop; since 1970, it has housed Rutgers Gun & Boat Center. The below photograph shows 137, 139, and 141 Raritan Avenue close to North Second Avenue. No. 137 was built in 1895 and was a candy store, a confectionery, a realtor's office, and in the 1990s, a bicycle shop. The middle building was originally the police headquarters and is now a delicatessen. The building on the right, built in 1901, was the firehouse and was converted into a dry cleaners in 1955.

10 North Second Avenue. Now the address of the expanded art gallery and frame shop B. Beamesderfer Gallery, the building at 10 North Second was built around 1915 as Hodge's Garage, an automobile service station. The large upstairs room was used as borough hall (1920–1923), and several civic organizations also met there. Dash Electronics, a TV repair shop, occupied this building from the 1950s to 2005.

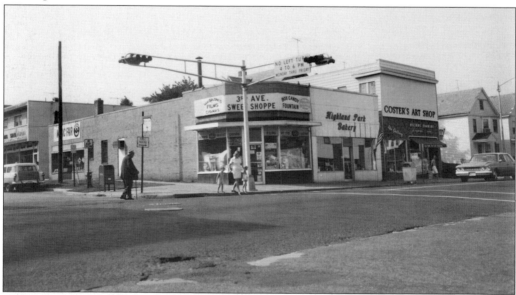

Third Avenue Sweet Shop. Victor Fais built the corner building at South Third Avenue (248 Raritan Avenue) in 1932. Fais ran the Third Avenue Sweet Shop until 1979, when it was taken over by the Williams family, who renamed it the Corner Confectionery. The adjacent buildings (246 and 242) were constructed earlier. In 1928, 242 Raritan Avenue was the original Pino's fruit shop (Coster's Art Shop in the picture). By 1930, the Great Atlantic & Pacific Tea Company (A&P) had opened a grocery store in 246, seen as the Highland Park Bakery in this picture.

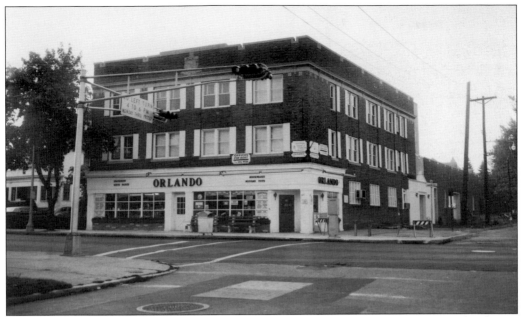

HIGHLAND PARK'S FIRST OFFICE BUILDING. This prominent corner building was designed by Alexander Merchant and built in 1920. In 1928, it housed an automobile dealer; by 1940, the post office. After the post office branch relocated around 1949, it became a general 5&10¢ store. Since this photograph was taken, there have been numerous changes as stores have come and gone, but it has remained primarily a commercial building with stores on the first floor.

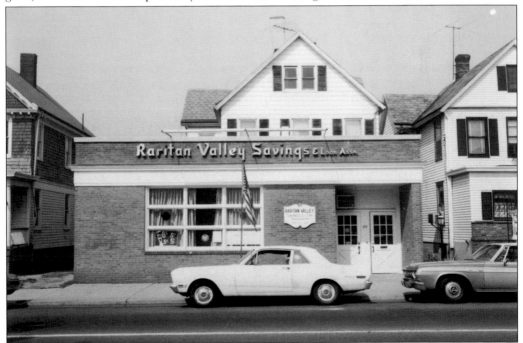

RARITAN VALLEY SAVINGS BANK. This is 307 Raritan Avenue as it looked in 1972, after Raritan Valley Savings Bank constructed a one-story brick addition to the front of a house built around 1910. The building has been remodeled and, since 1981, has housed the office of Rebarber Chiropractic.

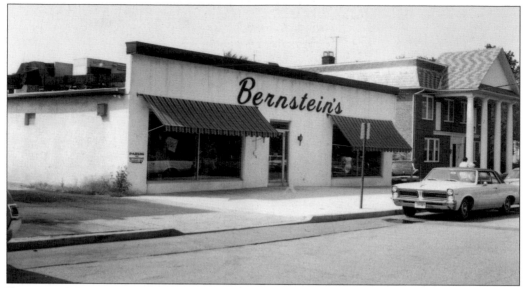

Bernstein's Dress Shop. Located just off the main street of Raritan Avenue, Bernstein's operated its dress shop on North Third Avenue for 45 years, from 1960 to 2005. Providing casual and formal dresses for all occasions, the shop allowed Highland Park residents to buy locally, not having to travel a great distance for clothing. The building was remodeled in 2008 and transformed into the Park Eye Center, an optometrist's shop.

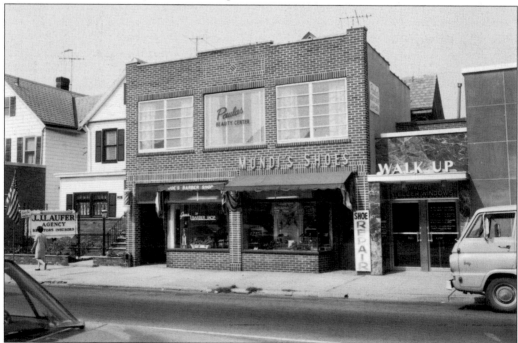

311–313 Raritan Avenue. In the years before adding a storefront at 309 Raritan Avenue in 1984, J.J. Laufer, a longtime local realtor, was located in an old house that was set back off the street. It is adjacent to the two-story brick storefront building at 311–313 Raritan Avenue, seen here in 1972, when it was the location of Joe's Barber Shop and Mundi's Shoes. A beauty salon, one of many in town, was located on the second floor.

DUTIES OF A MAYOR. Harold Berman (1920–2012) is the man with the scissors at this ribbon-cutting ceremony for an unidentified beauty parlor. A lifelong resident of Highland Park, Berman twice served as the borough's mayor: from 1976 to 1979 and 1984 to 1987. He was in the first graduating class of the high school in 1938 and wrote a marching song still used there.

AUSTIN E. GUMBS, HIGH SCHOOL PRINCIPAL. Austin Gumbs served as principal of Highland Park High School from 1971 to 1980, a time when many towns were merging neighborhood schools with the goal of improving integration. He was the first African American principal in Highland Park history. In 1978, a report for the Highland Park Desegregation Committee noted that Irving and Lafayette Schools had much larger percentages of students from low-income households than did Hamilton School. Gumbs became superintendent of schools in 1980 and guided the community as the Highland Park schools reorganized to a school system merged by grade. He retired in 1986.

Drill Team and Color Guard. Beginning around 1968, Commander Robert Love of the American Legion Post 88 started a color guard and drill team. Here, the members, unfortunately not identified, stand in full uniform in front of the post headquarters, then located at 808 Raritan Avenue. The participants were taught and regularly practiced ceremonial etiquette for events such as parades.

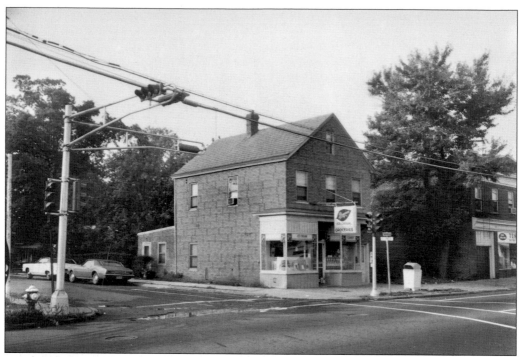

WOODBRIDGE AVENUE BUSINESSES. In 1930, John Schultz opened an auto repair business at 116 Woodbridge Avenue on the corner of South Eleventh Avenue (above). By 1937, Josephine Schultz was operating the store, conveniently located near Irving School, as a confectionery. Later, around 1949, this became Helen Schultz's grocery store. Across the street, Frank Lenetti opened a service station at 113 Woodbridge Avenue around 1937 (left). Seen here in a 1972 photograph, Lenetti is awarding a coveted banana-seat bike to a lucky winner. First built in 1963, these bicycles continued to be top sellers for companies such as Schwinn and Huffy well into the 1970s.

ADDITIONAL WOODBRIDGE AVENUE BUSINESSES. Peter Nanni opened his confectionery at 106 Woodbridge Avenue (above) around 1949 and remained there until moving across the street into a larger building. LaRosa Pizza now occupies this building. Reporter Nick Solares wrote that brothers Robert and Jack Hemmings and their cousin Jim Hemmings founded the White Rose System in 1958 and opened the original location at 158 Woodbridge Avenue (below). The trio parted in 1972, with Jim retaining the original Highland Park location and Jack and Bob opening individual restaurants in towns nearby. In 1972, White Rose relocated to its current diner-style building set back off the road next door. Handmade french fries and hamburgers with onions continue to be the most popular items on the menu.

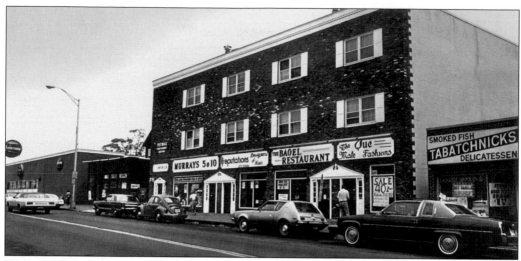

WALL-TO-WALL BUSINESSES ON RARITAN AVENUE. Despite being a state highway, Raritan Avenue has always been the main commercial zone in town. Pictured here from left to right are the original location of the Foodtown grocery store, a small storefront in front of an older house, the PetMar Building constructed in 1966, and Tabatchnick's Delicatessen. In 1987, Samuel G. Freedman, who grew up in Highland Park, wrote about hearing news and gossip at Tabatchnick's on Sunday mornings.

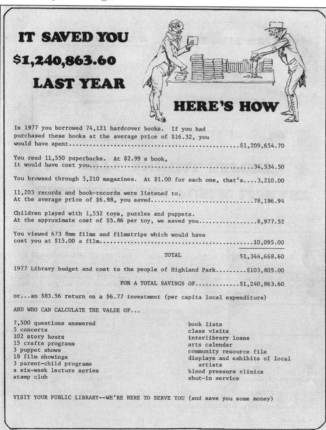

1977 PUBLIC LIBRARY ANNUAL REPORT. What better way to convince voters to support a local library than to show the advantages of collective ownership? Here is a detailed look at the total cost individuals would have had to pay to have the same services and experiences that the library provides. It was an effective campaign. The Highland Park Public Library continues to be one of the busiest community centers, unfortunately with the same need to justify taxpayer funding.

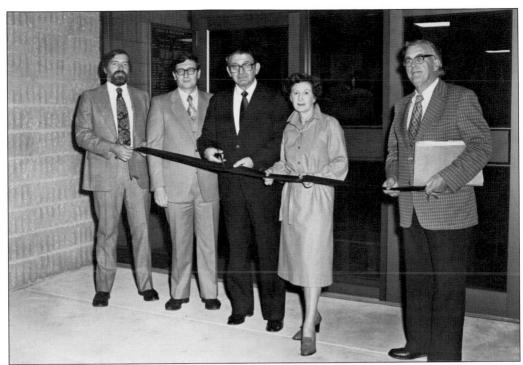

Mayor Berman at Another Ribbon Cutting. Mayor Harold Berman (above, center) presides at the 1979 ribbon-cutting ceremony of the new municipal building on South Fifth Avenue flanked by members of borough council. Berman stated in a 1998 oral history, "the new borough hall was built through my efforts and I am proud to say that not a dollar of local tax payer's money was spent to complete it because we obtained a federal grant." The building (below) was designed a decade earlier by architects Meyer and Laudadio. The tall building seen behind borough hall is senior citizen housing, and the fire department's monumental bell is in the right foreground.

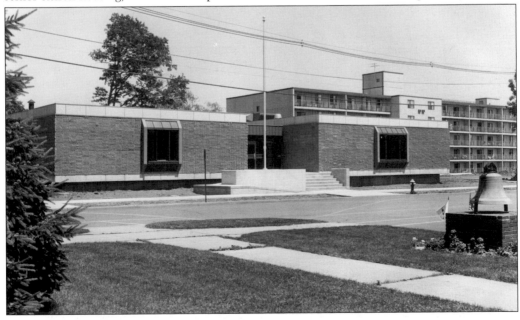

HIGH SCHOOL SPORTS. Former all-state quarterback Joe Policastro (class of 1959) became head football coach in 1978 after Jay Dakelman retired from the position. In this photograph (left) of a typical Friday evening in the autumn of 1979, the school mascot owl cheers on the home team. Policastro was fortunate to coach L.J. Smith, now with the Baltimore Ravens, who was a star of both the football and basketball teams in the 1990s. The football team won the NJSIAA Central Jersey Group I state sectional championships in 1986, 1989, and 1990. The high school is also known for its longtime success in boys' and girls' basketball. The photograph of the Owlettes below was also taken in 1979.

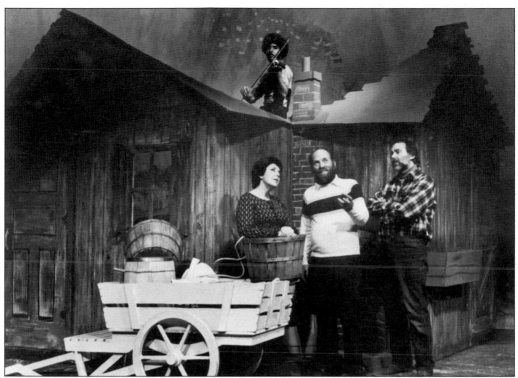

COMMUNITY THEATER. Cultural events in town have been well attended. For four evenings in March 1979, Highland Park was treated to a production of *Fiddler on the Roof*, a community theater event sponsored by the arts commission and the high school drama department. Some of the actors included Ed Yanowitz playing Tevye, Beatrice Adler playing Golde, Carole Eichenbaum playing the matchmaker Yente, and Gil Marshall as Lazar Wolf, the butcher. Daniel Z. Fisher was the Fiddler. The high school auditorium, part of Alexander Merchant's elegant plan of the school, is just off the main lobby as one enters the formal entryway.

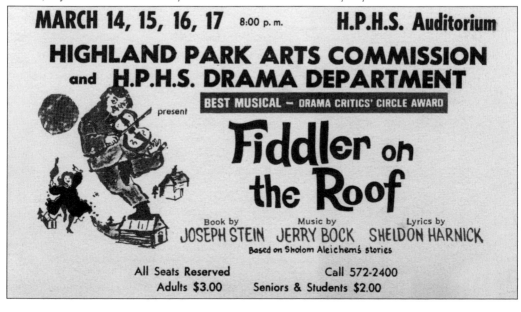

MARCH 14, 15, 16, 17 8:00 p.m. H.P.H.S. Auditorium
HIGHLAND PARK ARTS COMMISSION
and H.P.H.S. DRAMA DEPARTMENT
present BEST MUSICAL — DRAMA CRITICS' CIRCLE AWARD

Fiddler on
the Roof

Book by Music by Lyrics by
JOSEPH STEIN JERRY BOCK SHELDON HARNICK
Based on Sholom Aleichem's stories

All Seats Reserved Call 572-2400
Adults $3.00 Seniors & Students $2.00

113

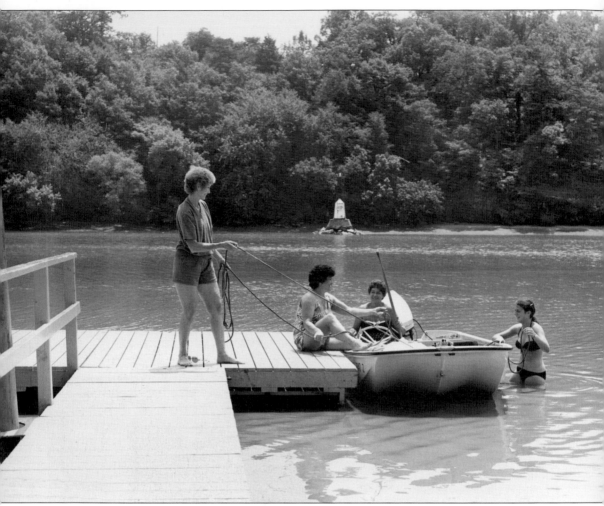

BOATING ON THE RARITAN RIVER. From left to right are Mamie Hackenberg, June McFarland, Norma Mason, and Marjorie Mason enjoying their launch from the Donaldson Park boat dock. The Raritan River has had a long recovery from all the damaging pollutants that were deposited there for many decades in the first half of the 20th century. In the 1970s, an environmental consciousness developed along with the Environmental Commission, and it has since grown stronger. Joseph Koye took this photograph for the League of Women Voters publication *This Is Highland Park*, but it was not included.

Six

THE LAST DECADES

HIGHLAND PARK TURNS
75. Although not as grand
a celebration as the events
that took place in 1955
when the town turned 50,
the symposium advertised
here in 1980 drew a crowd
of 400 residents. The first
annual Parkfest, held on
Memorial Day, May 26,
1980, was also dedicated
to the 75th anniversary
celebration; 2,500 people
strolled around the fair
set up in Donaldson Park.
Considered a success,
which led to others in
subsequent years, the
festival had a craft sale and
ethnic foods, musicians,
folk dancing, face painting,
mimes, and magicians.

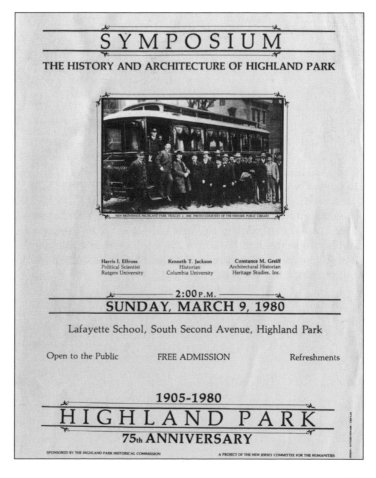

SYMPOSIUM

THE HISTORY AND ARCHITECTURE OF HIGHLAND PARK

NEW BRUNSWICK-HIGHLAND PARK TROLLEY c. 1900. PHOTO COURTESY OF THE NEWARK PUBLIC LIBRARY

Harris I. Effross	Kenneth T. Jackson	Constance M. Greiff
Political Scientist	Historian	Architectural Historian
Rutgers University	Columbia University	Heritage Studies, Inc.

2:00 P.M.

SUNDAY, MARCH 9, 1980

Lafayette School, South Second Avenue, Highland Park

Open to the Public FREE ADMISSION Refreshments

1905-1980

HIGHLAND PARK

75th ANNIVERSARY

SPONSORED BY THE HIGHLAND PARK HISTORICAL COMMISSION A PROJECT OF THE NEW JERSEY COMMITTEE FOR THE HUMANITIES

FIREFIGHTER MAKES AN UNUSUAL RESCUE. In 1982, Jerry Schultz, a Highland Park volunteer fireman and collector of related artifacts, found the 1919 LaFrance pumper truck Highland Park owned until 1961. Out of curiosity, Schultz followed a trail of sales until he pinpointed the owner in Fair Haven. Schultz struck a deal, and the fire department's reserve money brought the truck back to town. Parades and open houses feature this antique, shown here with Schultz at the wheel.

RARITAN AVENUE IMPROVEMENTS. This photograph shows the 1979 project of removing the Raritan Avenue cobblestones at the intersection of Raritan and Third Avenues. In 1984, a new system of tandem parking was instituted along the main street. This system has two spots together with 16-foot no parking zones in front and back allowing drivers to pull into and back out of spots without impeding the flow of traffic. The system is still in use today.

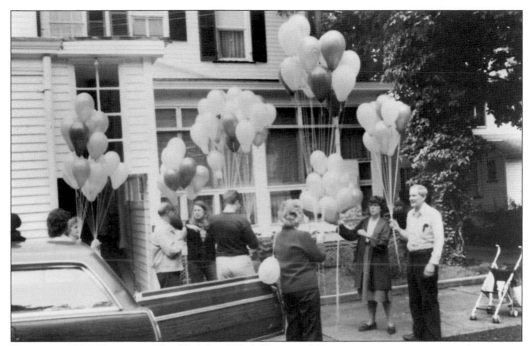

PARKFEST 1983 PARTIERS. The Highland Park Historical Commission was very active beginning in the 1970s. It started an archive, advocated for preservation, and conducted tours of Livingston Manor and South Adelaide Avenue. Here, several commission members are receiving balloons that they would hand out at the Parkfest parade. They also set up a display in Donaldson Park of the old photographs they had collected. Their work then made this book possible now.

NEW SYNAGOGUE UNDER CONSTRUCTION. In order to build a new synagogue to best serve its walking congregation, Ahavas Achim chose a large lot in a residential area on South First Avenue. Unfortunately, there was a large, 19th-century house on the lot that was not deemed compatible with modern architectural design. After heated community debate, the congregation received permission to demolish the house and build a synagogue, seen here under construction in 1986.

ENVIRONMENTALISM BEGINS IN EARNEST. As interest in environmental issues grew in the 1970s, the work of the Highland Park Environmental Commission and Shade Tree Commission grew in importance. Newspaper recycling became mandatory in 1984 after a year of voluntary bundling was deemed successful. The town and Rutgers University set up a system of composting bagged leaves beginning in 1984. Street trees were planted along Raritan Avenue, paid for by Ross Engineering. Longtime resident and environmental activist Arnold Henderson took these two photographs. The one at top shows the littoral area where the Meadows (east of Donaldson Park) meets the Raritan River; the lower one was taken on South Second Avenue as part of a study requesting grant money for trees to fill empty spots in various streetscapes.

THE BEAUTY OF NATURE. In March 1987, Arnold Henderson grabbed his camera and traveled to Highland Park's section of Johnson Park. In this photograph, he captured the beauty of nature even after a storm caused flooding and other damage to the park. He generously donated many of his nature photographs to the historical society before he moved out of town several years ago.

The
Highland Fling
Special Issue ——— Highland Park High School, Highland Park N.J. ——— Vol. LV May 22, 1987

IN MEMORIAM
William H. Donahue
1932 - 1987

by William Bloom with Steve Isakoff and Nick Taussig

They came en masse, students, teachers, alumni and community members, to bid farewell to their beloved principal and neighbor, William H. Donahue, whose untimely demise had left them shocked and saddened. It was a touching illustration of love and unity as, for a few hours, the town of Highland Park came together. As one alumnus put it, "It's great to see everyone. It's a shame it had to be for this."

On that evening, May 11, 1987, thousands took part in a procession to view the casket in the gymnasium. The night culminated with a candlelight vigil on the high school front lawn as the HPHS choir sang.

A resident of Highland Park all his life, Donahue graduated from Rutgers University in 1954 with a Bachelor of Science in the field of social studies. Donahue's teaching aspirations were put on hold for a three-year stint in the United States Air Force. As a navigator, he attained the rank of captain. While stationed in Massachusetts he met his future wife, Dorothy, whom he married in 1957.

While still in the Air Force, Donahue wrote to HPHS asking for a job: (October 20, 1956) "...I would like to put in an application for a teaching position in the Highland Park system...I must admit I am a little bit rusty but still very interested in the teaching field..." In September of 1957, he began his career in the high school as a social studies teacher.

It did not take long for Donahue to impress others with his tremendous enthusiasm and work ethic, as well as his overall leadership abilities. In recommending Donahue for chairperson of the Social Studies Department, former principal Harold R. Alley wrote (March 5, 1962): "...Mr. Donahue's leadership abilities have been exhibited in many areas. He is a highly qualified teacher with able administrative qualities. He is extremely well liked by students and staff members alike..."

From 1963 to 1972, he served as chairperson of the social studies department. Over this period, the department's curriculum was entirely remodeled and new courses were introduced. Donahue personally

developed three new courses: Anthropology, Sociology, and Selected Social Problems. During this time, he also received his Masters in history from Rutgers University.

The 1963 Albadome was dedicated to him, then student congress advisor, "In appreciation of his outstanding service to Highland Park High School and his sincere interest in the student body."

Former Superintendent of Schools Roy D. Loux, in thanking Donahue for his work as chairman of the Middle States Evaluation Committee, wrote, January 7, 1970, "...I feel you did an excellent job...It is through this kind of effort by members of our staff that Highland Park has the excellent school system of which we are all proud."

From there, he went on to be administrative assistant to the high school principal. He remained in that position for only a year, moving on to serve as administrative assistant to the superintendent. In 1978, he took over the job of assistant principal.

In 1978, Donahue became principal of the high school, a post he never wished to leave until his retirement. It is interesting to note that when rumors surfaced that he would become superintendent, Donahue quickly quelled them by saying, "I would hate to leave my position as principal. I enjoy being around the kids too much." He had planned to retire in June of 1988.

He and his wife of 30 years had three children. Kerry, Erin, and Sean all attended HPHS. Donahue held his family in utmost importance. A colleague, and Donahue's neighbor of 16 years, John Gallino puts it, "The family was more than friendly but there was a special bond that existed between them." Gallino goes on to say, "They had many friends but usually chose to celebrate holidays together, in private."

There were other sides to William Donahue. A weekly churchgoer, Donahue was a charter member of the St. Theresa's Church in Edison. In addition, he was chairperson of the Highland Park Board of Trustees from 1959 to 1965. He served on the Rutgers Land Utilization Committee for three years. From 1972 to 1978, he was trustee to the Highland Park Public

Library. For a time, he served as chairperson of the Highland Park Bicentennial Committee. And in 1980 he was president of the Highland Park Exchange Club.

Donahue was known for the great warmth and compassion that he exuded on a daily basis. He was more than just principal.

Senior Todd Auerbach comments, "I think people are right when they say he was more than just a principal; he was a father. Like a father, he knew when to be strict and when to be understanding."

Sophomore Pete Sugleris adds, "He wasn't just a principal. He was a friend. He was very understanding and kind to all. He always had a smile."

"He was the nicest man in the school," says junior Brian Lewis. "He cared about all the students and the faculty; and we all cared about him. I'll always remember him."

In his speech at the vigil, former superintendent and long time friend of Donahue, Austin Gumbs said, "The outpouring of love is amazing — It's brought Highland Park to a new height it has never reached before."

Although the phrase "learn something" was Donahue's trademark, maybe it is the following statement that holds even more meaning to the people of Highland Park: "A town's identity centers around its school." For on a cool spring night the town of Highland Park showed what its school system and its friend and principal, William H. Donahue, meant to them.

May 9, 1987

Highland Park High School's beloved principal, William H. Donahue, was fatally stabbed once in the back Saturday, May 9, according to police. Donahue, who served as HPHS principal since 1980 and had lived in Highland Park for all of his 55 years, was killed trying to break up an argument between one of his daughters and her ex-boyfriend.

According to Middlesex County prosecutor Alan Rockoff, Donahue's daughter Erin, 22, returned home from an engagement at about 1:30 a.m. Shortly thereafter, Rockoff said, John J. Peplinski, Jr., 24, a former boyfriend of Erin, came to Donahue's door. After Erin tried to keep him out, he forced his way into the house and a confrontation between the two ensued. After hearing the commotion, Donahue and his wife Dorothy came downstairs to aid their daughter, Rockoff said.

According to Rockoff, Donahue's struggle with Peplinski ended in the kitchen, where Peplinski drew a hunting knife and stabbed Donahue. Donahue bled to death at the scene.

Highland Park police received a call from Donahue's wife at 2:07 a.m. Peplinski was sought by police from 2:15 a.m. until 5:50 a.m. when he turned himself in at the Highland Park Police station. He was taken to the Middlesex County Adult Correction Center in lieu of $500,000 bail.

Donahue is survived by his wife Dorothy, two daughters, Erin and Kerry, and a son, Sean.

A scholarship fund has been established in Donahue's name. Donations may be sent to Highland Park High School, payable to the William H. Donahue Scholarship Fund.

HIGH SCHOOL NEWSPAPER'S TRIBUTE TO A BELOVED PRINCIPAL. Homicides are rare here, but on May 9, 1987, high school principal William H. Donahue was stabbed to death in his home. Samuel G. Freedman, who grew up in Highland Park, wrote a tribute article for the *New York Times* on May 31, 1987. He stated, "it challenged some cherished assumptions about the town where I was born and raised, and also about myself, the dispassionate reporter of other people's tragedies." John Peplinski Jr. was tried and convicted of the killing and remains in prison.

WVHP, THE VOICE OF HIGHLAND PARK. Established in 1971, the high school radio station WVHP operated at 90.3 on the FM dial. Several radio personalities got their start here, including Ken Friedman, WFMU general manager; Soterios Johnson, local host for NPR's *Morning Edition*; and Bob Sommer, at KALW in San Francisco. Both Jim Axelrod, now with CBS News, and Willie Paszamant (actor Willie Garson of *Sex and The City*) lent their voices to the airwaves with shows on WVHP.

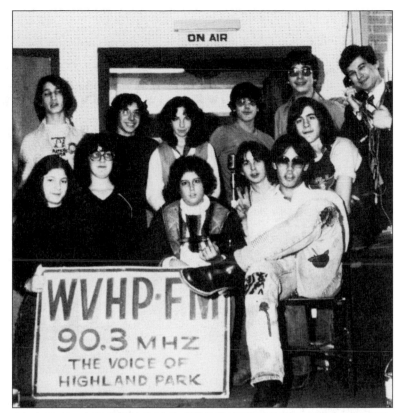

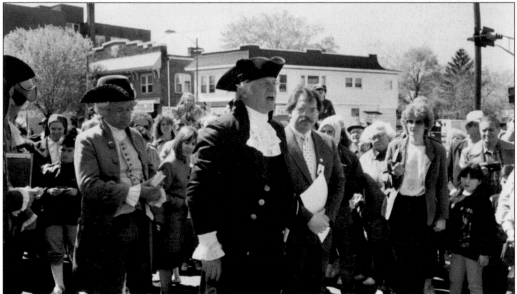

GEORGE WASHINGTON WAS REENACTED HERE. On Saturday, April 22, 1989, Gen. George Washington, played by Philadelphia actor William Sommerfield, made a stop in Highland Park on his journey to New York to be inaugurated as president of the United States. Here, he and some of his militiamen drew a substantial crowd, which included Mayor Jeffrey Orbach (to the right of Washington). Orbach served as mayor from 1988 to 1991.

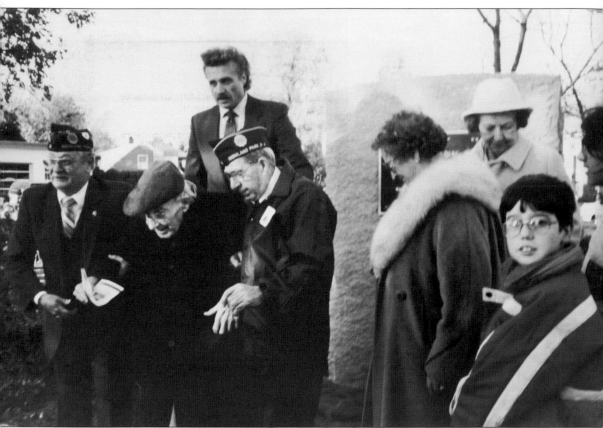

VETERAN'S MEMORIAL PARK. The unveiling of a granite monument to accompany the World War I doughboy statue at the intersection of Woodbridge and Raritan Avenues took place on November 12, 1989. This unveiling was part of a larger refurbishing project of Veterans' Memorial Park. Lois Lebbing donated this snapshot. From left to right are ceremony participants Frank Conover, Korean War; Ernest Fette, World War I; Charles Dascenzo, Vietnam War; Thomas Loyacano, World War II; Marguerite Wheatley Tudor and Kathleen Wheatley Nichols, sisters who unveiled the doughboy in 1921 (see page 27); and poetry contest winners Gilad Engelberg and Bobbie Theivakumaran.

HIGHLAND PARK ARTS COMMISSION. Another active group during the last decades of the 20th century was the Highland Park Arts Commission. Driven by art and music lovers, this group has been responsible for hosting cultural events such as art exhibits, concerts, plays, lectures, poetry readings, and field trips. Here are two posters announcing concerts in 1988 and 1989. Venues included the library and borough hall, as well as the high school auditorium. The arts commission also created a directory of local artists and regularly sponsors open studio weekends.

The Highland Park Arts Commission presents:

THE REGENCY RAGTIMERS

An 8 piece band specializing in music of the Ragtime era

Sunday, November 20, 1988
3:00 PM
Highland Park High School
Auditorium

Free Admission

BRIGHT MOMENTS

A JAZZ CONCERT

Funding for this group by NJ State Council on the Arts/ Dept. of State and the Geraldine R. Dodge Foundation

PRESENTED BY THE HIGHLAND PARK ARTS COMMISSION in celebration of "BROTHERHOOD WEEK"

Sunday, February 12 2:00 pm
Robert W. Stevens Auditorium
Highland Park High School

NEW FIRE ENGINE NO. 4, C. 1992. This photograph of firefighters in front of a pumper truck is one of a series taken around 1992 during the engine's delivery. New mayor H. James Polos (with the microphone) spoke at the gathering. Polos, who would be mayor for two terms from 1992 to 1999, started his involvement in local politics with an appointment as civil defense director in 1981.

HISTORIC PRESERVATION LOSS. It always comes as a shock when a demolition crew takes away a historic building a community fought to save. This was the case with Highland Park; its building missing here was called the Brody House. Designed by Alexander Merchant in 1910, it stood as a welcome sign to all visitors who came into town after crossing the Raritan River (see page 75 far right at the top). After years of benign neglect and community advocacy for the town to take possession, it was deemed a fire hazard and demolished in November 1997.

REMODELING A LIBRARY. During the early 1990s, a fundraising campaign bore fruit in a much needed expanded public library. The architects incorporated some of the 1959 structure and added height and width. A cladding of brick and white-painted trim turned a flat modern building into a Colonial style building (above). The reopening took place in October 1993; Louise Deis took the snapshot below of Rita Bettenbender, Aileen Coffey, Ellen Mappen, Eugene Young, and Marc Mappen, among others.

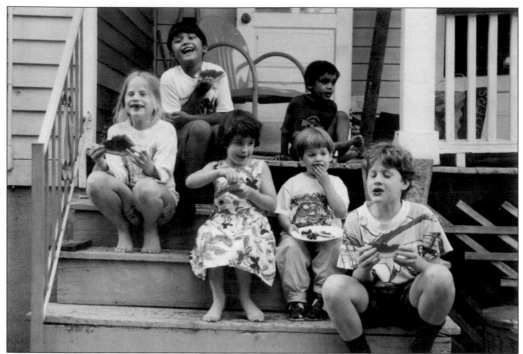

SCHOOL'S OUT FOR SUMMER. What could be more fun on a hot summer day than to sit on the back porch steps to cool off with chilled watermelon and a seed-spitting contest? Summer days in Highland Park can be brutally hot; luckily, many houses still have porches. Here, the Rice, Montelione, and Sarker children are having fun visiting each other in June 1995.

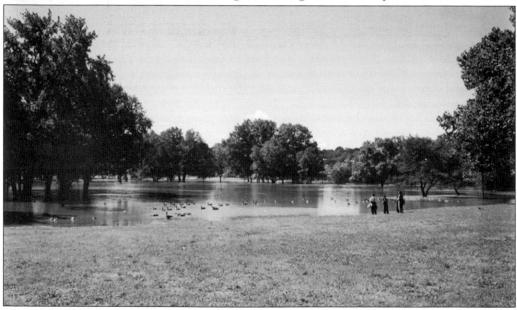

HURRICANE FLOYD, 1999. On September 16, 1999, Hurricane Floyd paid a visit to the east coast of the United States. Rainfall in the Highland Park area averaged around 10 inches, and the Raritan River basin experienced record flooding as a result of Floyd's heavy rains. Much of the land of Donaldson Park is a flood plain, and the park was closed for two days due to waist-high water.

CONSERVED MONUMENT. After standing at a busy intersection for 80 years, the World War I doughboy monument had accumulated decades of dirt and road grime. In 2001, the town hired a professional conservator who carefully removed the dirt and then added a protective patina. After the unveiling on November 11, 2001, the group of organizers, borough council members, and Mayor Meryl Frank (on the far right) posed for this photograph. Frank was the town's first female mayor and served from 2000 to 2010. The ceremony came just one month after the attack on New York's World Trade Center that nearly took the life of one Highland Park resident. That event will have to be at the start of the next history: *Highland Park in the 21st Century.*

Discover Thousands of Local History Books
Featuring Millions of Vintage Images

Arcadia Publishing, the leading local history publisher in the United States, is committed to making history accessible and meaningful through publishing books that celebrate and preserve the heritage of America's people and places.

Find more books like this at
www.arcadiapublishing.com

Search for your hometown history, your old stomping grounds, and even your favorite sports team.

Consistent with our mission to preserve history on a local level, this book was printed in South Carolina on American-made paper and manufactured entirely in the United States. Products carrying the accredited Forest Stewardship Council (FSC) label are printed on 100 percent FSC-certified paper.

MADE IN THE USA